IMAGES
of America

CITRUS
COUNTY

IMAGES
of America

CITRUS
COUNTY

Lynn M. Homan and Thomas Reilly

ARCADIA

Published by Arcadia Publishing,
an imprint of Tempus Publishing, Inc.
2 Cumberland Street
Charleston, SC 29401

Printed in Great Britain.

Library of Congress Catalog Card Number: 2001087138

For all general information contact Arcadia Publishing at:
Telephone 843-853-2070
Fax 843-853-0044
E-Mail sales@arcadiapublishing.com

For customer service and orders:
Toll-Free 1-888-313-2665

Visit us on the internet at http://www.arcadiapublishing.com

CONTENTS

ACKNOWLEDGMENTS

In telling this story of Citrus County, we received help from a number of organizations and individuals. First and foremost, the volunteers and staff of the Citrus County Historical Society deserve our thanks. President Dan Quick and the board of directors lent their endorsement to the project, while Bob Bamford, chairman of the publications committee, arranged our access to the valuable photographic and archival resources of the society. No matter how busy, Kathy Thompson, director of museum services, answered innumerable questions and fulfilled every request for assistance with unfailing good humor and enthusiasm. Carol Buckner and Jill Kersey also did whatever possible to make our task easier. Invaluable assistance was provided by Esther Yonkin and Vernina Gray, volunteers in the society's photo archives, who located hundreds of images for us. Mary Craven of the Citrus County Tourist Development Council contributed a number of wonderful contemporary photographs. Residents, both past and present, of Citrus County, including E.C. May, David Arthurs, Tom Ritchie, John Eden Jr., Richard England, Mary MacRae, and Hampton Dunn, also performed a most valuable service by recording for researchers their accounts of the history of the area. To everyone who helped in whatever way, we extend our appreciation.

INTRODUCTION

For the first inhabitants of what is today known as Citrus County, the area must have been a "Paradise Found." There were crystal-clear spring-fed rivers, gently rolling hills, and thousands of acres of virgin forest. To the west was the Gulf of Mexico. To the east was the Tsala Apopka chain of lakes, some 23,000 acres in volume and approximately 22 miles in length. The fertile land was rich with wild game such as deer, bears, and of course, alligators. The waters teemed with fish of all kinds; turtles and oysters were plentiful. Life was good . . . and then the Europeans arrived on the scene.

The one thing that this place that would someday be Florida didn't have was what the newcomers really wanted—wealth in the form of gold, silver, and precious gems. That quest for treasure first brought Spanish conquistadors to the state in the 16th century. Juan Ponce de León, reputedly the first European to set eyes on Florida, found neither riches nor even his hoped-for fountain of youth in his explorations of 1513 and 1521. Was de León's disappointment enough to stem the invasion of European treasure hunters? Of course not. Ponce de León was soon followed by a succession of Europeans hoping to succeed where he had failed.

The rush was on, and neither the lack of precious metals nor the deaths of their fellow treasure hunters did anything to dissuade them. Pánfilo de Narváez and his expedition explored the western coast of central Florida in 1528. As had other Spanish conquistadors, Narváez and his men skirmished with the Native American inhabitants. He found no gold and, along with almost all of his men, died during his quest. In 1539, Hernando de Soto and his well-equipped expedition of more than 700 people landed at Tampa Bay and began their trek through west central Florida. On a journey through Florida, Georgia, South Carolina, Tennessee, Alabama, Mississippi, Texas, and eventually Mexico, his party is believed to have passed through present-day Citrus County. De Soto fared no better than his predecessors had. He too failed to discover treasure and died during his expedition. The French would not be any more successful along the Atlantic coast of Florida.

Although the Spanish were the first Europeans to visit the state, they were by no means the first inhabitants of the area. Paleoindians inhabited Florida, including the area surrounding Cardinal Pond, some 12,000 years ago. Archaeological evidence indicates that members of the Deptford culture first came to Crystal River around 200 B.C. Native peoples of the subsequent Weeden Island and Safety Harbor cultures would continue to occupy until A.D. 1400 what is considered to be Florida's most famous pre-Columbian archaeological site. Today, visitors to

the Crystal River State Archaeological Site can still see the stelae (carved ceremonial stones) and midden, temple, and burial mounds left behind by these first residents.

While their quests for treasure may have been unsuccessful for the Spanish explorers, the consequences of their visits were devastating to the native inhabitants of Florida. At the time of de Soto's expedition, Florida was home to more than 350,000 Native Americans, belonging to hundreds of different societies. For example, just in the region around Citrus County, the area north of the Withlacoochee River was the territory of a group collectively known as the Timucua. Originally referring to the common language shared by a number of separate tribes, the name was subsequently used by the Spanish to identify all that spoke that dialect. South of the Withlacoochee, centered on Tampa Bay and extending south to Charlotte Harbor, members of the Safety Harbor culture were the dominant group. Within the next 200 years, warfare, enslavement, and especially epidemics of European diseases led to the virtual disappearance of the native population. Adding insult to injury, subsequent "modern civilization" would eradicate most of the archaeological traces of a way of life that had lasted thousands of years, as ceremonial mounds and middens were destroyed for use as road-paving materials in 20th-century Florida communities.

As Florida's native inhabitants disappeared, members of the Lower Creek Indian tribe living in Georgia and Alabama moved into northern Florida in search of both land and freedom from tribal conflicts with the Upper Creeks. Their immigration encouraged by the Spanish, by 1760, the Lower Creeks in Florida had come to be known as Seminoles. Other Indians, the Yuchi and Yamasee, as well as black slaves escaping from Southern plantations, also moved into the area. In the next few years after their 1814 defeat by Andrew Jackson, an influx of Upper Creeks swelled the Creek and Seminole population in Florida. When the United States took control of the region from Spain in 1821 following the finalization of the Adams-Otis Treaty of 1819, Americans quickly expanded their settlements into Florida.

As conflicts escalated between the Indians and settlers, the Treaty of Moultrie Creek resulted, restricting the Seminoles to the central part of Florida, including present-day Citrus County. In 1830, the government passed the Indian Removal Act, providing for the relocation of southeastern Native Americans to what is today Oklahoma. When the Indians refused to leave Florida, federal troops were sent to enforce their removal. Between 1835 and 1842, a series of commanders, tribal leaders, skirmishes, battles, and treaties combined to form the conflict known as the Second Seminole War. By its end, only a few hundred of more than 6,000 Seminoles remained in Florida; the rest had been killed or forcibly removed to the West. What was termed "the Indian problem" had been resolved in favor of the settlers. Florida statehood would soon follow in 1845.

Life was still not idyllic, however. In the middle of the 19th century, one old-timer expressed widely held sentiments on the subject of someone moving to Florida: "Well, ye probly won't get back. Them there bad men'll kill ye, er the 'gators'll eat ye, or the skeeters'll give ye malary an' that'll kill ye." Like the rest of the state, the area that is now Citrus County suffered its share of problems. There were bugs, snakes, and alligators, occasional unseasonable winter freezes, and, more often, muggy summer heat. There were also outlaws and unscrupulous land agents with deals that were invariably too good to be true. To be sure, the land could be harsh and unforgiving, but there was also great promise for those pioneers hardy enough to venture into the unknown. The Armed Occupation Act of 1842 promised that any man "who settled in peninsular Florida below a cross-state line located about 10 miles south of Newnansville [Gainesville] and was willing to keep a gun and ammunition, build a house, cultivate five acres of land, and live there for at least five years, would receive a patent for 160 acres." Between the government-sponsored land program and the eradication of any threat from the Indians, west-central Florida's door was wide open.

To be sure, a few Americans had already moved into the area, as evidenced by the settlement of Red Level around 1820 and Homosassa in the mid-1830s. The populations of these communities were small, however, and would remain so. Even with the enticement of free land

under the Armed Occupation Act, growth in the region was a slow process. There were few major cities; most people lived on the farms and in the woods where they could make a living from the land. Lecanto came into being around 1860. Hernando was founded in 1881, followed by settlement of Floral City in 1883. Inverness was founded around 1885. Mannfield was established a year earlier and soon became the first county seat following the creation of Citrus County in 1887. Still other early towns appeared briefly, only to fade into obscurity and disappear. Look on a map for Mount Lee, Bridgers, Orleans, Mannfield, Stage Pond, Fairmont, Arlington, Oakdale, Rose Hill, Viana, or Mallards Mill. Today, they simply do not exist. By 1890, the total population of Citrus County was only 2,394 people.

On June 2, 1887, Gov. Edward Aylsworth Perry signed a law dividing Hernando County into Hernando, Citrus, and Pasco Counties. With a total population of slightly over 4,000 people, the three-county area was still frontier territory. Only five years earlier, George M. Barbour had accompanied Ulysses S. Grant to the state. In his *Florida For Tourists, Invalids & Settlers*, Barbour provided a less than complimentary description of the region's inhabitants. He wrote, "The entire trip that day was through an unsettled region, the only human beings living anywhere along the road being four or five families of Florida natives, the genuine, unadulterated cracker—the clay-eating, gaunt, pale, tallowy, leather skinned sort—stupid, stolid, staring eyes, dead and lusterless; unkempt hair, generally tow-colored; and such a shiftless, slouching manner, simply white savages—or living white mummies would, perhaps, better indicate their dead-alive looks and actions." It was not a very flattering description of early Citrus County settlers. By the beginning of the 20th century, promotional materials intent on luring both visitors and new residents would present a much more glowing description of the area and its inhabitants.

Over the years, most ways of earning a living have been based upon the land and the nearby waters. Farming, fishing, lumbering, citrus growing, raising of livestock, and even tourism have all helped to provide a cash economy for the people of Citrus County at one time or another. Rich in natural resources, the area had practically perfect weather for raising an almost limitless variety of crops. Cotton, sugar cane, rice, peanuts, pineapples, as well as the more mundane vegetables such as corn, peas, potatoes, tomatoes, watermelons, and beans, were grown. As farms grew in size and yields increased, subsistence farming gave way to commercial production for expanded markets. At the same time, thousands of acres of virgin timber provided the raw materials for companies producing raw lumber, cedar pencils, wooden crates, and turpentine products.

Fishing also began on a small scale, providing food for individual households, and eventually expanded to statewide markets. Although in recent years, most of the commercial fishing industry has succumbed to the combined pressures of decreasing catches, pollution, net bans, environmental regulations, and the high cost of fuel and fleet maintenance, Citrus County is still heavily dependent upon its lakes, rivers, and the Gulf of Mexico. Today, however, the waters serve not so much as a source of food but as a draw for its tourist-based economy.

Early developers had big hopes for the county's namesake—citrus. Just as in many other Florida communities, growers planted thousands of acres with orange and grapefruit trees. And just as happened elsewhere in the state, the great freeze of the winter of 1894–1895 devastated the citrus industry and bankrupted many farmers. Although a few hardy souls with sufficient financial resources replanted, the detrimental temperatures arrived with sufficient regularity to insure that citrus growing never regained major commercial viability.

Phosphate mining provided the real industrial boom in Citrus County at the beginning of the 20th century. Of the phosphate business, the *Polk County News* wrote, "It is like the enchanted isle of Monte Cristo or the wealth of Croesus—phosphate, phosphate, thou are a treasure." The discovery of phosphate had brought an economic rush to central Florida. For a time, Citrus County communities resembled the gold mining towns of the Old West, complete with the accompanying lawlessness, bad elements, murderers, gamblers, and wicked women. As thousands of people made their livings in the phosphate mines, African-American men did

much of the backbreaking labor. The small town of Floral City swelled to a population of 10,000 people, most of whom were dependent upon the industry. In 1910, there were at least 34 phosphate plants in operation in Citrus County. Unfortunately, the outbreak of World War I curtailed the European demand for phosphate. Following the war, the market never revived, and the industry died in the county.

Even up into the 1920s, the living conditions in a very rural Citrus County were Spartan. Malaria continued to be a problem. Sanitation was poor; a short supply of ice left many people with no way to keep food cold. With the completion of the power plant at Inglis in 1927, the widespread distribution of electricity became possible; until then, many rural residents relied on kerosene or oil lamps for lighting. As was the case everywhere in Florida, the Great Depression hit Citrus County hard. While relief programs assisted the aged, blind, and those truly in need, the Works Progress Administration programs provided employment for many of those in Citrus County in need of work. WPA projects played a major role in paving the roads of Citrus County, as well as in the construction of bridges, public buildings, playgrounds, and several area schools.

Today, the economy is drastically different. Although Citrus County's economic base continues to be derived in part from mining, agriculture, retailing, construction, and service industries, the main business of the still largely rural region is rapidly shifting to tourism. Visitors are drawn not by theme parks and mega-resorts, however, but by the natural resources of the area. Open spaces abound, making Citrus County a magnet for those who enjoy a day in the woods or on the water. Crystal River National Wildlife Refuge, Chassahowitzka National Wildlife Refuge, Fort Cooper State Park, Crystal River State Archaeological Site, Yulee Sugar Mill Ruins State Historic Site, Homosassa Springs State Wildlife Park, and the Withlacoochee State Forest all provide vacationers, campers, and day explorers with opportunities to commune with nature or relive historic events.

As it was over a hundred years ago, much of Citrus County is still defined by its small towns, rolling hills, green pastures, and thousands of acres of woodlands. Approximately one-third of the land is protected, thanks to numerous federal, state, and county projects. The area is home to 27 species of mammals, 35 kinds of fish, 41 species of reptiles, and hundreds of varieties of birds. Still surviving in this less developed corner of Florida, many animals, such as the Florida black bear, scrub jay, red cockaded woodpecker, peregrine falcon, and Southern bald eagle, have been placed on lists of either threatened or endangered species. The West Indian manatee, which makes its winter home in the warm waters of Citrus County, serves as the poster child for all of these disappearing creatures. Seven rivers, the Salt, Rainbow, Withlacoochee, St. Martins, Homosassa, Crystal, and Chassahowitzka, run through Citrus County; several originate within the county in bubbling springs that flow at a year-round constant 72 degrees. Along with Lake Tsala Apopka, all offer unparalleled canoeing, boating, and fishing to both year-round residents and visitors. It is easy to see why the 682-square-mile Citrus County is described as "Mother Nature's Theme Park."

One wag commented either seriously or facetiously that "Citrus County is boring and has no history." That is just not so. The county may not have any truly big cities. No significant Civil War battles were fought there. Settlement by Europeans was relatively late in coming to the area. Nevertheless, there is history, and it is anything but boring. Sophisticated early native cultures called the area home long before the dawn of modern civilization. The buried remains of mastodons and saber-toothed tigers provide additional evidence of a prehistoric presence. Spanish conquistadors suffered countless disappointments looking for gold and other nonexistent riches as they explored the region. Fort Cooper came into being during the Second Seminole War. Hardy pioneers carved an existence from the Florida wilderness. Thousands took part in the boom-and-bust of numerous industries. Florida newcomers today find homes in the county's planned communities. Vacationers are drawn to the natural beauty of "the real Florida." Traces of "old Florida" remain. Significant historic structures are being restored and preserved for future generations. The story of Citrus County continues to unfold.

One

IN THE BEGINNING

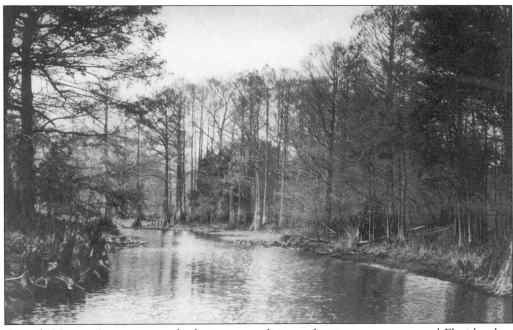

As early Native Americans made their way south into what is now west central Florida, they must have felt that they were entering a pristine semi-tropical paradise. Imagine Citrus County as it must have appeared to those first inhabitants—an abundance of wildlife, dense timber-filled forests, cypress swamps, crystal-clear rivers, and bubbling springs. Fortunately, for both residents and visitors, many of those natural resources remain unspoiled today in what is described as "Mother Nature's Theme Park." Appearing much the same as it did hundreds and even thousands of years ago, this particular scene can still be viewed along any one of the rivers and lakes throughout the county. Lining the riverbanks are towering cypress trees, their bases surrounded by knobby projections known as cypress knees. (Citrus County Tourist Development Council.)

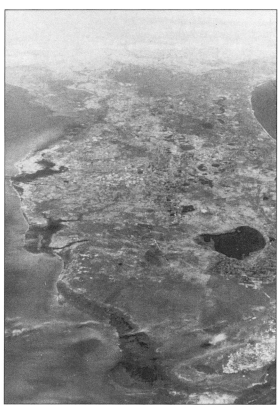

Florida is an elongated peninsula extending from the United States mainland into the waters of the Atlantic Ocean and Gulf of Mexico. This was quite apparent when the STS-51C mission crew snapped this photograph of the state from high above the Earth in January 1985. While imaging technology has certainly advanced, even a casual glance shows a marked resemblance to a map of Florida drawn by French cartographer Hieronimus Chiaves more than 400 years earlier. (National Aeronautics and Space Administration and Florida State Archives.)

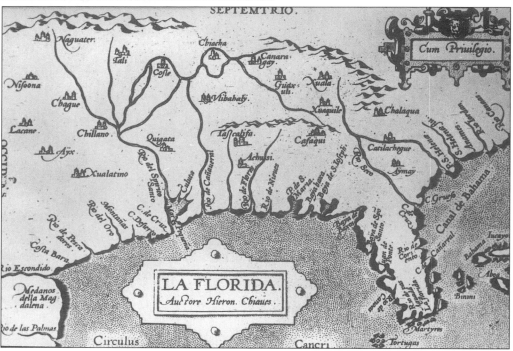

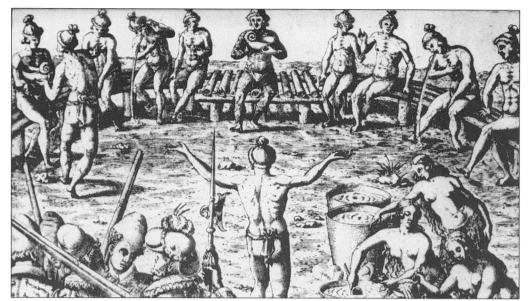

Spanish explorer Ponce de León opened Florida's doors to Europeans in 1513. Subsequently Pánfilo de Narváez and Hernando de Soto led expeditions through west central Florida, including, it is believed by many, portions of Citrus County. By 1562, a French settlement had been established at Fort Caroline near St. Augustine. Published in 1591, Theodore De Bry's engravings of drawings by Jacques Le Moyne provided the first depictions, although somewhat exaggerated in style, of Florida's Native American inhabitants. (Florida State Archives.)

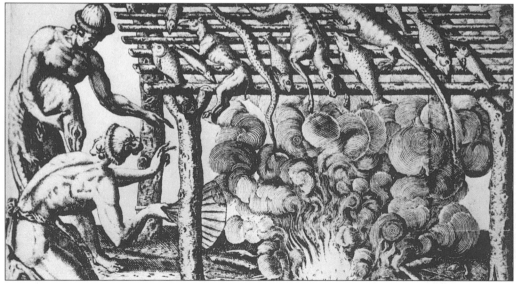

At the time of de Soto's expedition in 1539, Florida was home to more than 350,000 Native Americans, belonging to hundreds of different societies. In the region around Citrus County, the area north of the Withlacoochee River was the territory of a group collectively known as the Timucua. South of the Withlacoochee, members of the Safety Harbor culture were the dominant group. By 1750, warfare, enslavement, and especially epidemics of European diseases caused the virtual disappearance of the native population. (Florida State Archives.)

Numerous Citrus County locations contain evidence of the county's very earliest inhabitants, both animal and human. Fossilized remains of mastodons, three-toed sloths, and other prehistoric creatures can still be found at abandoned phosphate mines and in caves, long popular as spots for exploration and picnics. In this particular photo dating from February 1929, Walter Homes is pictured exploring Lecanto's Saber-Tooth Cave. (Florida State Archives.)

The Native Americans encountered by the Spanish conquistadors weren't the first people to live in Florida, however. Much of what is known about the earliest human inhabitants of the area stems from the painstaking work of teams of archaeologists. Significant discoveries include the Cardinal Pond, Tatham Mound, Powell's Town, Tiger Tail Island, Shell Island, Mullet Key, Buzzard Island, Roberts Island, and Crystal River State archaeological sites. (Citrus County Historical Society.)

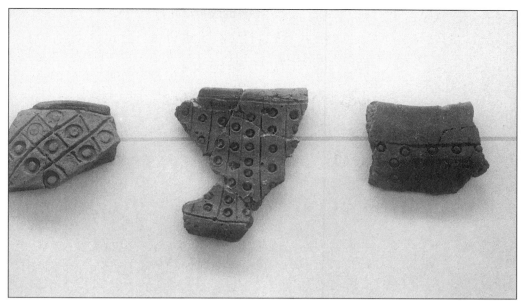

Through careful examination and documentation of minute artifacts and their location, archaeologists are able to create a picture of the past. Multi-layered midden mounds reveal details of everyday life thousands of years ago in much the same manner as an analysis of our own household debris yields clues about our daily activities, while ceremonial sites tell stories of the organization and rituals of these early societies. (Authors' Collection.)

A National Historic Landmark, the 14-acre Crystal River State Archaeological Site was used by Native Americans for more than 1,600 years beginning around 200 B.C. Initial archaeological investigations by Clarence B. Moore in 1903 revealed the site's importance as a ceremonial center. One of the most prominent features remaining today is a large temple mound, originally measuring approximately 182 by 100 feet at its base and reaching nearly 30 feet in height. (Citrus County Historical Society.)

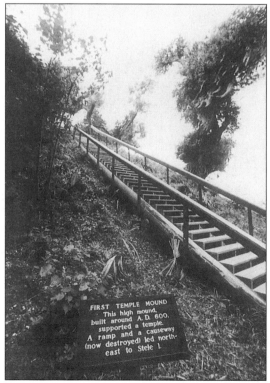

FIRST TEMPLE MOUND
This high mound,
built around A.D. 600,
supported a temple.
A ramp and a causeway
(now destroyed) led north-
east to Stele 1.

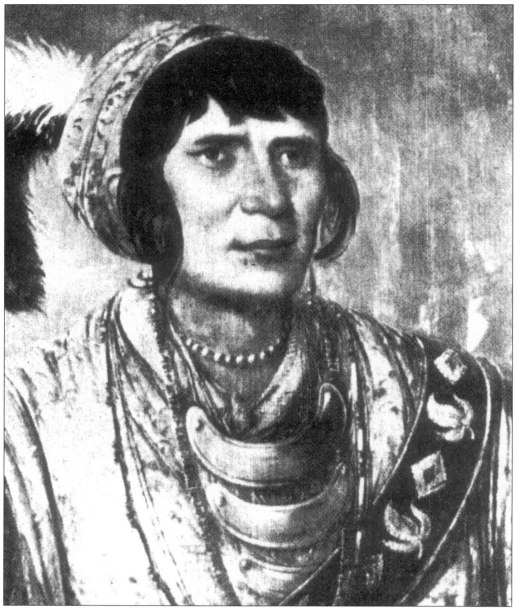

Warfare, enslavement, and especially epidemics of European diseases led to the virtual eradication of the native population. As Florida's original native inhabitants disappeared, other Indians, including the Yuchi, Yamasee, and members of the Upper and Lower Creek tribes, moved into Florida and came to be known as Seminoles. Conflicts between the Indians and settlers led to the Treaty of Moultrie Creek, restricting the Indians to the central part of Florida, including present-day Citrus County. In 1830, the government passed the Indian Removal Act, providing for the relocation of southeastern Indians to what is today Oklahoma. When the Seminoles refused to leave, federal troops were sent to enforce their removal. Between 1835 and 1842, the Second Seminole War raged. Well-known artist George Catlin painted this portrait of Osceola, one of the most famous of the Seminole leaders, in 1838. (Florida State Archives.)

Reenactments take place each year at Fort Cooper State Park, a 710-acre site named for Maj. Mark Anthony Cooper, commander of five companies of the First Georgia Battalion of Volunteers during the Second Seminole War. In April 1836, Cooper and his men constructed a frontier fort on the shores of Lake Holathlikaha, holding it for 16 days against repeated Seminole Indian attacks until reinforcements arrived from Fort Brooke near Tampa. Their struggle became the longest single battle of the campaign. (Visualizations/Terrell Photographs.)

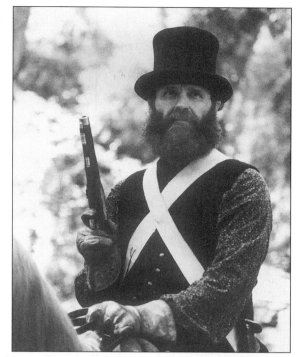

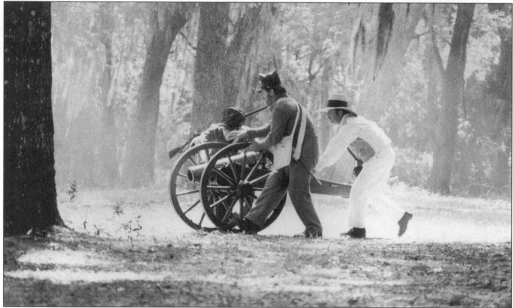

Refusing to leave their homeland despite government orders, the Seminoles had taken refuge in the Cove of the Withlacoochee, a 135-square-mile area bordered by the Withlacoochee River and the chain of Tsala Apopka lakes. The efforts of General Winfield Scott and his troops to "punish and defeat" the Seminoles and remove them from the Cove would take nearly six more years. The State of Florida acquired the property in 1970 for use as Fort Cooper State Park. (Visualizations/Terrell Photographs.)

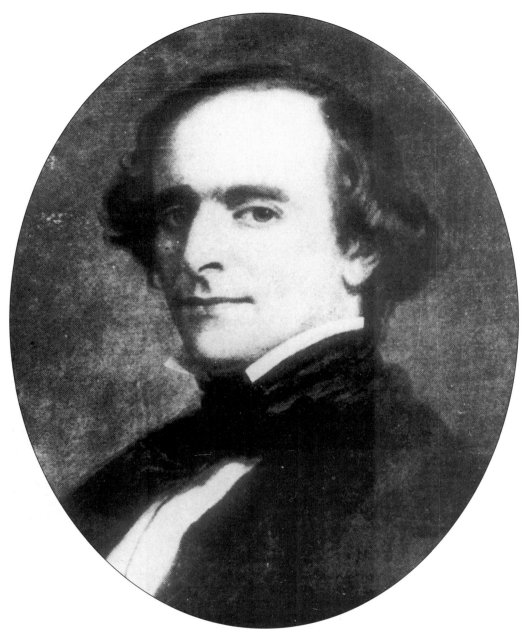

Appearing in the October 11, 1886 issue of the *Washington Post*, David Levy Yulee's obituary described him thusly, "to have belonged to a far-off and almost nebulous period, when before the War Between the States as Senator from Florida, he was better known than the State that he represented. He was a man of great vitality, and though a generous liver was a prudent abstainer." Born in the West Indies, Yulee was a man of many dimensions—a plantation owner, attorney, and politician. In 1860, he built one of Florida's first railroads, the Atlantic and Gulf Railroad, extending from Fernandina to Cedar Key. A leading proponent of Florida statehood, Yulee served as one of the state's first U.S. senators from 1845 until the onset of the Civil War. (Citrus County Historical Society.)

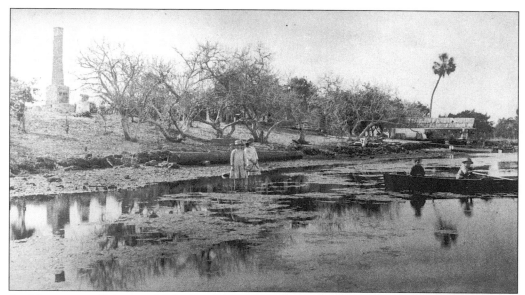

At Homosassa, Yulee established a 5,100-acre plantation and sugar mill in 1846. Named "Margarita" in honor of his wife, Margarita Wickliffe Yulee, the plantation and mill utilized as many as 1,000 workers and in 1863, produced 185,000 pounds of sugar. In May 1864, Union troops burned the Yulee residence on Tiger Tail Island. Although the mill was undamaged, production ceased permanently. (Citrus County Historical Society.)

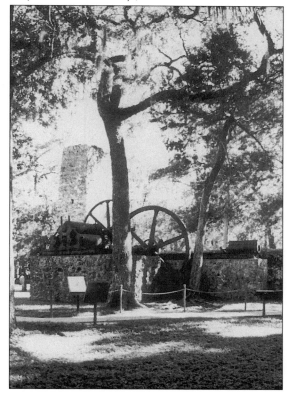

Located on Fishbowl Drive in Old Homosassa and operated today as a state historic site, the Yulee Sugar Mill ruins have been partially restored. The massive limestone chimney, metal boiler, and pieces of grinding equipment that still remain quietly tell a story of a prominent family and a local industry disrupted by war more than a century ago. (Citrus County Tourist Development Council.)

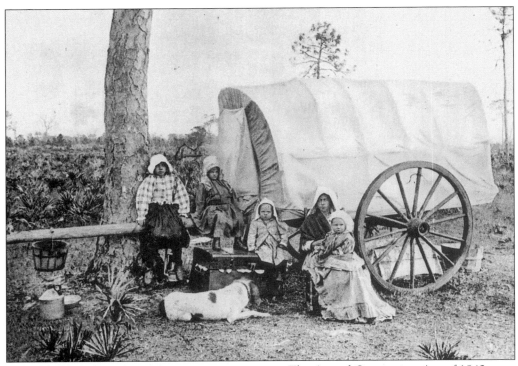

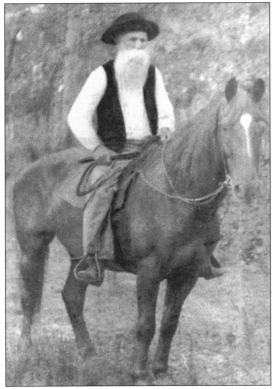

The Armed Occupation Act of 1842 offered free land to homesteaders; the eradication of any threat from the Indians made life on the Florida frontier a little safer. Red Level had been settled around 1820 and Homosassa in the mid-1830s. Lecanto came into being around 1860. Hernando was founded in 1881, followed by settlement of Floral City in 1883. Inverness was founded in 1885. (Citrus County Historical Society.)

Among the newcomers to the area that would become Citrus County were a number of Civil War veterans seeking a fresh start in life. In 1873, former Confederate soldier and prisoner of war Henry V. Taylor left Georgia with his wife and children to form one of the pioneer households in the Hernando area. (Citrus County Historical Society.)

Another Civil War veteran, U.S. Gen. Joshua L. Chamberlain, brought his leadership skills to the Homosassa area in 1884. Having served several terms both as governor of Maine and as president of Bowdoin College, Chamberlain moved to Florida to regain his health. In partnership with John Dunn and other investors, he headed the Homosassa Company, intent on developing the area as a vacation spot for northern visitors, complete with railroad access and a resort hotel. (Citrus County Historical Society.)

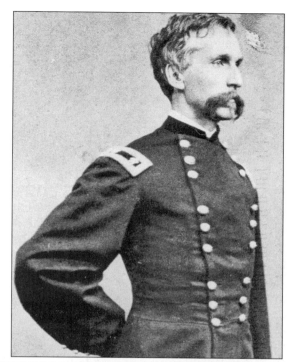

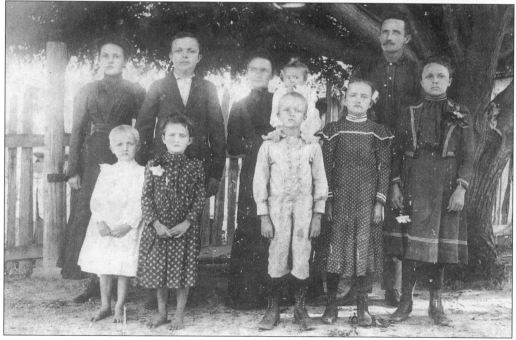

William Allen; his wife, Ellen Davis Allen; and their children comprised another Citrus County pioneer family. Although the Allens were the proud parents of 14 children, only 8 are pictured here. Allen was a successful farmer and cattleman in the Lecanto area at the beginning of the 20th century. (Citrus County Historical Society.)

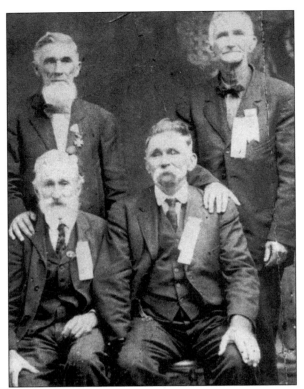

A Civil War Confederate veteran, Alfred D. "Alf" Tompkins, (upper left, pictured with his brothers) first acquired a large tract of land in 1868 and established the small community of Tompkinsville. After he sold 160 acres in the early 1880s to a group of local businessmen that included his brother-in-law Frances Dampier, they developed nearby Inverness. Since only a street separated the towns, petitioners favoring the postal designation of Inverness prevailed and the towns merged. (Citrus County Historical Society.)

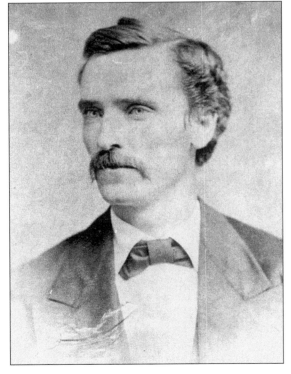

Austin S. Mann, elected to the Florida senate in 1883, might well be considered the father of Citrus County. The driving force behind the creation of the county in 1887, Mann ran afoul of the faction that wanted to move the new county seat from Mannfield to Inverness. When opponents branded him an aristocrat, he failed in his bid for reelection to the state senate. Selling off his holdings, he left the area permanently. (Citrus County Historical Society.)

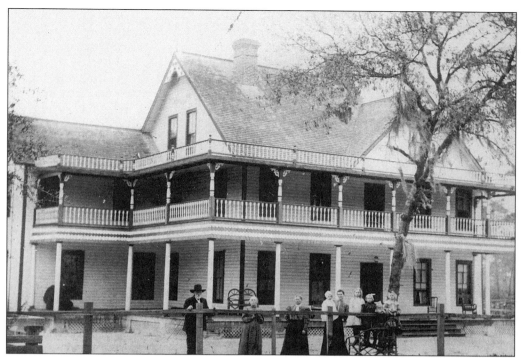

Fronting onto Northeast Tenth Street in Crystal River, the Mann-Miller-Holder residence stands on property owned by A.S. Mann in 1883. R.J. Knight and his wife, Mae, purchased the property and added 11 rooms, 3 baths, and a wide hallway to the house before selling it to Charles Miller, the local postmaster and cashier of the Bank of Crystal River. The Millers' daughter Elsie Miller Holder owned the dwelling until the early 1980s. (Citrus County Historical Society.)

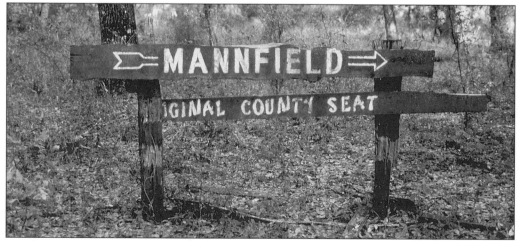

Until recently, a sign in the Withlacoochee State Forest pointed the way to the long-forgotten town of Mannfield. First settled in 1883 and named in honor of State Senator A.S. Mann, the small community approximately two miles south of Lecanto became the first county seat after Citrus County became a separate entity in 1887. Today, there is nothing left of Mannfield. (Citrus County Historical Society.)

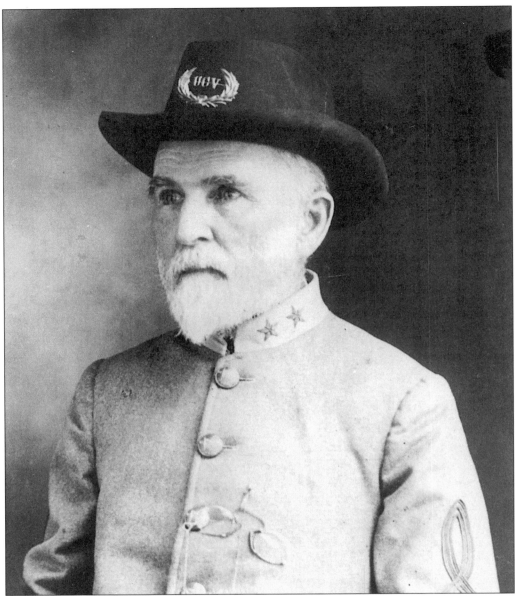

Like many Citrus County settlers, William C. Zimmerman and his wife moved to Florida after the Civil War. With the creation of Citrus County, the Confederate veteran was elected as the first clerk of the circuit court. On May 4, 1891, voters chose to relocate the county seat from Mannfield to Inverness, a move opposed by Senator Mann and his supporters, including Zimmerman. While officials argued about the decision, a mob of anti-Mann activists took matters into their own hands. According to local lore, with vigilante-like action, the mob effected the move. When Zimmerman refused to surrender either records or office furnishings, the men picked him up, still seated in his chair, and loaded him aboard a wagon for the trip to Inverness. The tale continues that Zimmerman did not resist since the sheriff, Jim Priest, had ordered him not to move. Whether or not the story is true, Zimmerman continued to serve as the clerk of the circuit court until 1901. (Citrus County Historical Society.)

Two
FACES AND PLACES

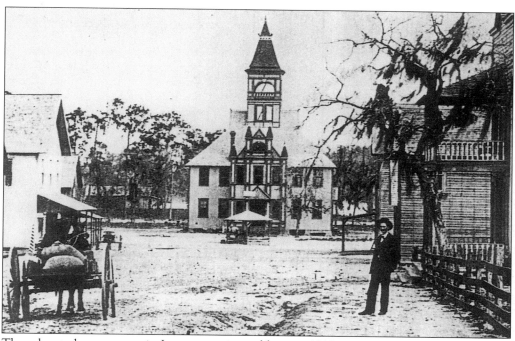

The relocated county seat in Inverness, pictured here in 1892, was just one of several thriving communities in Citrus County at the end of the 19th century. While none could be deemed a metropolis by today's standards, many small towns, frequently having been established around a particular industry, dotted the area. In the case of some of the county's "ghost towns" such as Arlington, Orleans, Fairmount, and Vienna, when the activity ceased or new modes of transportation improved access to other areas, the towns disappeared. Other communities such as Inverness, Hernando, Crystal River, Homosassa, and Floral City still exist as population centers today. As is always the case, it is the people, both prominent and less well known, who make communities desirable places to be. (Citrus County Historical Society.)

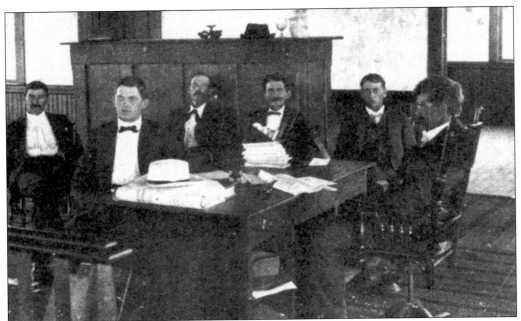

Several of the first men to serve as Citrus County commissioners following the relocation of the county seat from Mannfield to Inverness posed for this formal portrait. As was frequently the case throughout Florida at that time and is still true in some communities today, a number of the county's leading businessmen held political office while simultaneously engaging in commercial enterprises. (Citrus County Historical Society.)

Based upon records of officeholders of the period, this photograph of county officials was taken around the turn of the 20th century. Pictured on the steps of the 1892 courthouse in Inverness, from left to right, are the following: (front row) G.J. Boswell, tax assessor; Walter F. Warnock, clerk of the circuit court; George Carter, deputy sheriff; G.W. deMuro, judge; and A.T. Priest, sheriff; (back row) B.F. Wilson, county treasurer; Capt. W.C. Zimmerman, deputy clerk; and H.L. Brooks, tax collector; (Citrus County Historical Society.)

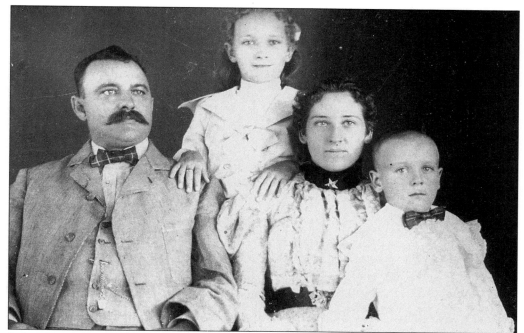

Judge George W. deMuro, his wife Josie, and their children posed for a family portrait typical of the era. Born in Cuba in 1864, deMuro moved to Baltimore, Maryland, with his family four years later. As a young man, deMuro traveled to Florida, settling in Citrus County and entering the citrus business. His initial public service was as a county commissioner and a justice of the peace. (Citrus County Historical Society.)

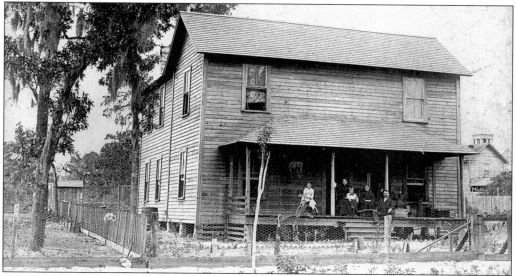

The deMuro family home was located on West Main Street in Inverness. One of the organizers of the Florida Orange Canal and Transit Company, George deMuro was appointed to fill an unexpired term as a probate and county judge. He continued to serve as a judge for 25 years until his death in 1917. Continuing the family tradition of public service, his son later served as mayor of Inverness. (Citrus County Historical Society.)

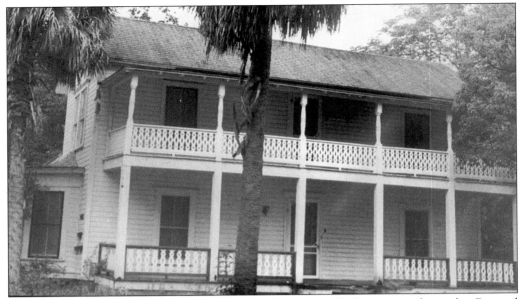

Francis M. Dampier helped to lay out the town of Inverness. His house, once located at Bay and Lime Streets in Inverness, reflected many modern innovations. Built in 1880, it was the first home in the area to be built of sawn lumber. The residence had 10 rooms, 3 fireplaces, glass front doors, and lapped wood siding, undoubtedly manufactured at Dampier's sawmill. The residence was razed in 1987. (Citrus County Historical Society.)

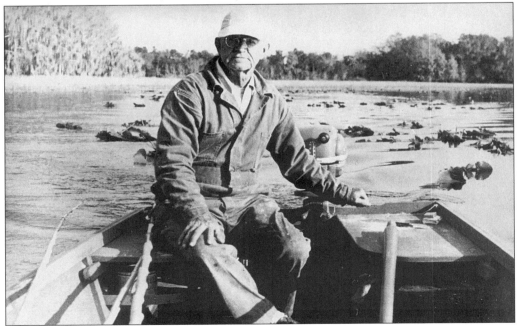

Earl Gilmore Dampier, pictured during a fishing expedition on Lake Tsala Apopka, was one of Francis Dampier's five children, all of whom were born in the family home just discussed. In 1914, Earl Dampier became one of the co-owners of the Evergreen Hotel in downtown Inverness. (Citrus County Historical Society.)

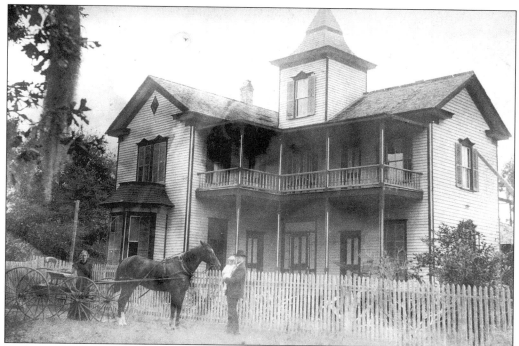

A fine example of Folk Victorian architecture, the Warnock House in Inverness was constructed by the Reverend J.P. Wilson. The house was also the residence of Walter F. Warnock, who served as Citrus County clerk of court from 1901 until 1919. Warnock, the son of Inverness's first physician, Robert F. Warnock, and the son-in-law of J.P. Wilson, was also an early owner and editor of the *Citrus County Chronicle*. (Citrus County Historical Society.)

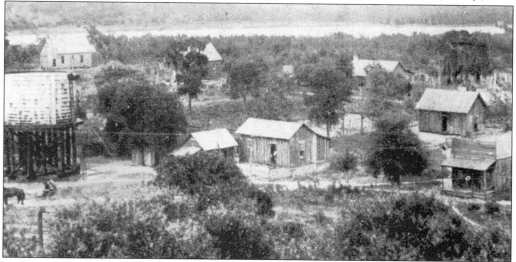

By 1911, as evidenced in this northeastern view from the courthouse in Inverness, the city had grown by leaps and bounds since its settlement in the 1880s. Churches, schools, hotels, a new jail, and other structures had become part of the landscape. Living conditions were still pretty basic, however, with poor sanitation, a short supply of ice, and no electricity as standard fare for many residents. (Citrus County Historical Society.)

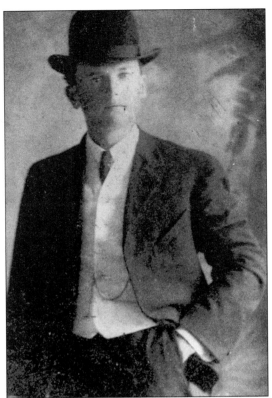

Born in Georgia in 1868, Ellis Connell May came to Citrus County in 1892. He owned and operated a general store in Hernando until 1898, then moved to Dunnellon where he was a shopkeeper until 1901. Following several years in California, May returned to Citrus County and eventually opened a store on West Main Street in Inverness. First elected county judge in 1916, E.C. May served, at one time or another, as state representative, state attorney, and county judge until his retirement from government service in 1949. His two books, *Gators, Skeeters, and Malary* and *From Dawn to Sunset*, still serve as histories of early Citrus County. One of the area's biggest boosters for nearly 60 years, May once reflected, "Citrus County is as near Utopia as we are going to find." (Citrus County Historical Society.)

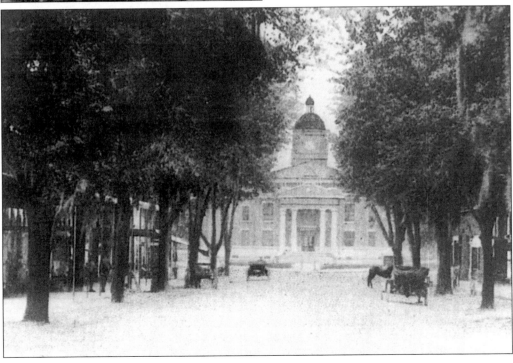

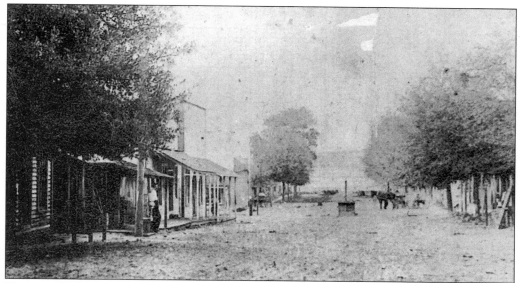

Photographed in 1902, Hernando appeared to be a sleepy little Southern town. The quiet Main Street offered the town well along with a handful of stores. Appearances were deceiving, however. Named for Spanish explorer, Hernando de Soto, the town bustled with hordes of phosphate miners who had come to the area in hopes of striking it rich. Reportedly a bell was rung each evening to warn female residents to leave the streets since the occasionally rowdy miners were on their way home from work. (Citrus County Historical Society.)

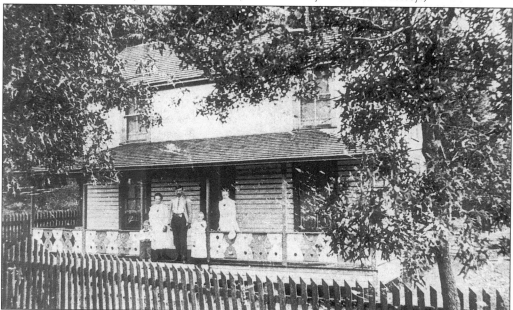

Richard M. Spires and his first wife, Leonora, sat on the porch of the elegant new house in Hernando that they built in 1892, replacing their 12-by-18-foot log cabin homestead. Spires had a varied career as a merchant, farmer, cattleman, and postmaster. Following Leonora's death, Richard Spires married Ethel Carrington, who had a career of her own as a *Citrus County Chronicle* correspondent for nearly 30 years. (Citrus County Historical Society.)

Moving from Red Mill, Pennsylvania, Daniel W. and Amelia B. Pheil homesteaded nearly 900 acres near what would soon become Floral City. According to family members, the Pheil household was the first in the community to have an indoor cook stove. When Amelia died on August 11, 1884, her husband buried her on high ground away from the lake, establishing a burial ground known today as the Hills of Rest Cemetery. The Pheils had four children—William, John, Abram, and Harvey. John became a furniture maker whose designs are displayed currently at the Edison Museum in New Jersey. Harvey relocated to Cordele, Georgia. Both William and Abram Pheil left Floral City and moved to St. Petersburg where Abram was elected mayor in 1912. Two years later, Abram had the distinction of becoming the initial passenger on the St. Petersburg-Tampa Airboat Line, the world's first regularly scheduled commercial airline. (Citrus County Historical Society.)

David Alonzo Tooke came to Floral City with his family when he was just a young man. Near the end of the Florida land boom, Tooke, the owner of a large tract of land on Duval Island, sold the property to Floral Islands, Inc., the development project spearheaded by L.G. Ferris. Among Tooke's other business ventures were a fruit stand and large store located on Orange Avenue. Both he and his wife were also actively involved in civic affairs. (Citrus County Historical Society.)

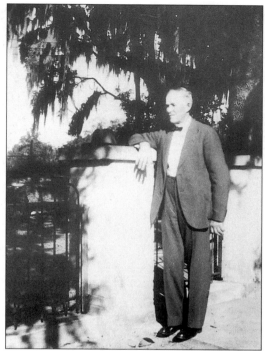

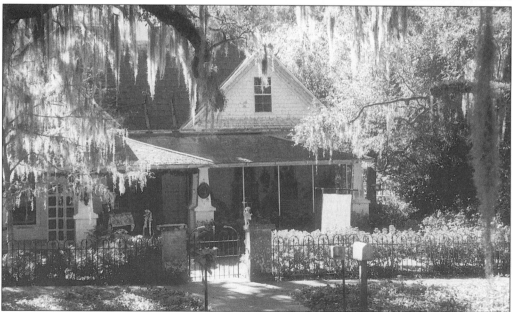

The D.A. Tooke residence, 8560 East Orange Avenue in Floral City, was originally built for H.D. Bassett, the superintendent of the Black Diamond Phosphate Mine. Although remodeled, the home still retains many of its original distinctive features. In 1937, for the sum of $30, Tooke bought from the county the ornamental iron fence that currently surrounds the property. Until that date, the fence had encircled the Inverness courthouse. (Citrus County Historical Society.)

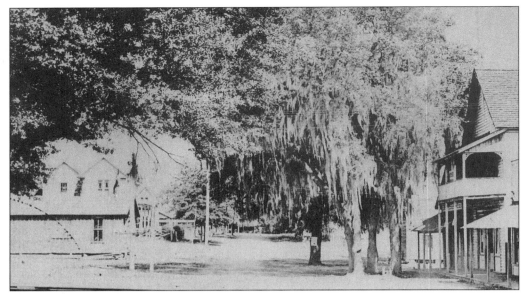

In this pre-1913 view of Floral City's Orange Avenue near the intersection of U.S. 41 and C.R. 48, the streets are still unpaved. Following the arrival of the railroad in 1893, the community's commercial center relocated from Aroostook Avenue to this part of town. Unfortunately, the outbreak of World War II, the demise of the phosphate industry, and a fire in 1920 destroyed much of the activity. The old hotel, in the background on the left side of the street, still exists today, although all of the buildings pictured on the right have disappeared. Orange Avenue remains unparalleled anywhere in Florida today, however. Although many of the buildings lining the road are historically significant, it is the magnificent overhanging canopy of oak trees that makes Orange Avenue famous for its beauty. (Citrus County Historical Society.)

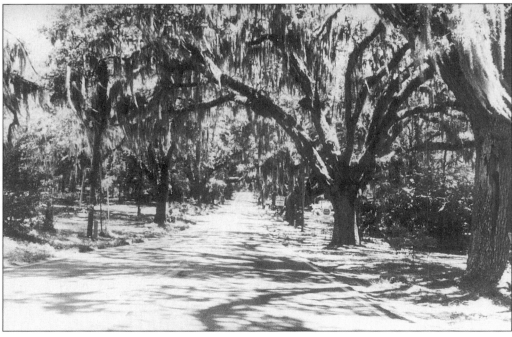

Arthur and Clementine Norton were certainly two of Floral City's most influential pioneer residents. Born in Tallahassee in 1877 to a former slave, Arthur Norton came to Floral City in 1900 to work in the phosphate industry at the Ten Cent Mine. Upon his death in 1986 at the age of 109 years, he was believed to be the county's oldest resident. A founding member of the Mount Carmel Methodist Church, he was well known in both the white and black communities as a compassionate man, tireless in his aid to those in need. The mother of nine children, his wife Clemmie died in 1952. While discussing the treatment of African-American residents of Florida in the early 20th-century, Arthur Norton recalled a fishing trip along the Suwannee River. "I once saw a black man standin' on the bank of the Suwannee tryin' to catch a fish. A white man came by and hit him hard on the head and pushed him in the water. He drowned. I cried about that." (Citrus County Historical Society.)

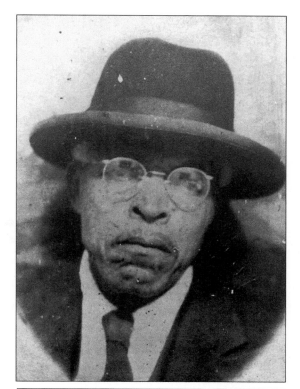

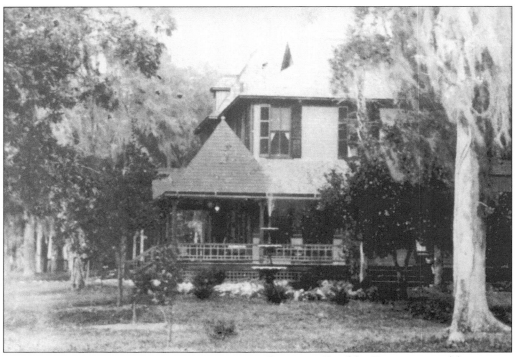

Benjamin Franklin Dutton, a wealthy Bostonian and an avid hunter and fisherman, enjoyed the Citrus County countryside so much that he commissioned the construction of a seasonal vacation residence in Homosassa. Located along the Homosassa River, the elaborate dwelling was named "Riverside Lodge." B.F. Dutton was the president and founder of Houghton & Dutton, Boston's first major department store. Opening in 1874, the store, a forerunner of today's malls, offered one-stop shopping and boasted of having more than 13 acres of floor space. In Citrus County, Dutton was a partner, along with Joseph Chamberlain and John F. Dunn, in the Homosassa Company. With the intention of developing the area, the group purchased much of the land once owned by David Levy Yulee. (Citrus County Historical Society.)

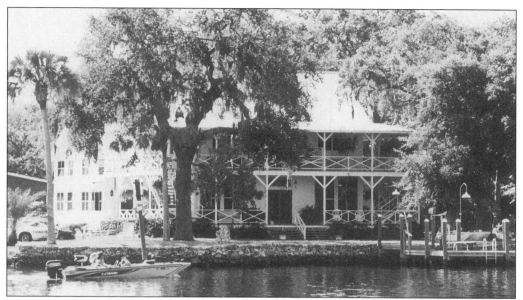

Built by land agent and developer John Dunn in 1882, the Homosassa Inn was a sportsmen's lodge visited by notables such as John Jacob Astor, Winslow Homer, and Thomas Edison. James and Mary MacRae purchased the structure in 1919 with the provision that the previous owner, Helen Richardson, be permitted to live there until her death. In 1932, the MacRae family reopened the house as a lodge and later a restaurant. By the mid-1990s, family members had once again converted the Homosassa Inn to a private home. (Citrus County Historical Society.)

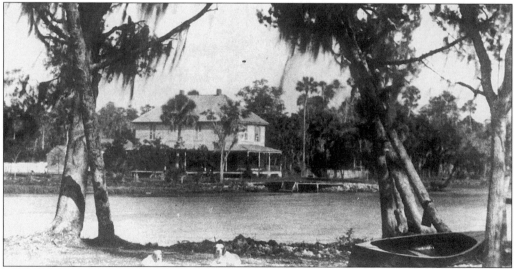

Owned by several different families since its construction in the late 1800s, this property was once best known as the Crump Fishing Lodge. A private residence until 1906, it was purchased and operated as a fishing lodge first by the Udells and then by the Fisher family. Kebbie Charles Crump purchased the property in 1942, renaming it the Crump Fishing Lodge and opening a restaurant called the Side Yard where he offered a selection of fresh fish and vegetables. (Citrus County Historical Society.)

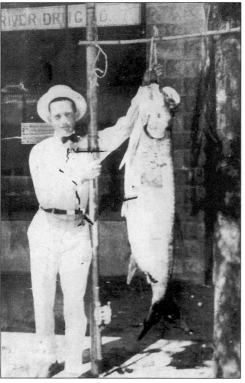

The view from the Thomas Hoy residence on Citrus Avenue presented an idyllic look at life in Crystal River around 1910. Since their arrival in 1889, the Hoys had helped to build the town into a pleasant village offering department stores, churches, a school, and hotels. Employment was easy to find—Joseph Dixon Crucible Company, Oxford Crate, Ox Fiber Company, and Crystal Ice Company all offered plenty of jobs for eager workers. Early Board of Trade literature touted the "Beautiful Crystal River, with its millions of fish for the entertainment of the sportsman tourist." Great fishing was enjoyed not only by tourists. Standing in front of the Crystal River Drug Company, Tommy Hoy proudly displayed what he undoubtedly believed to be a record catch. (Citrus County Historical Society.)

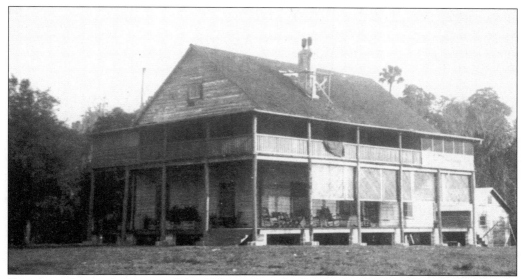

Constructed around the turn of the 20th century, the Sparkman-Van Roy House served as the residence of two of Crystal River's most influential families. N.N. Sparkman and his brother operated Sparkman Brothers' Store and were active in local politics. N.N. Sparkman served as the town's mayor on three separate occasions. The home was later purchased by Frederick Van Roy, "The Tall Pine From Citrus," a state representative, owner of a crate company, and well-known land developer. (Citrus County Historical Society.)

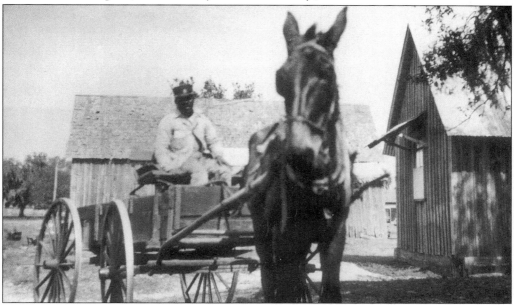

With his mule-drawn wagon, William S. Ford was a familiar sight in Crystal River for many years. He was the undertaker for local African-American families, served as deliveryman for Edwards Brothers' Store, and carried mail for the post office. Upon his death at the age of 72, his obituary stated, "Most any time you could look out and see Ford with several little white children in his wagon, who loved to ride around with him whether he was delivering his groceries or carrying the mail." (Citrus County Historical Society.)

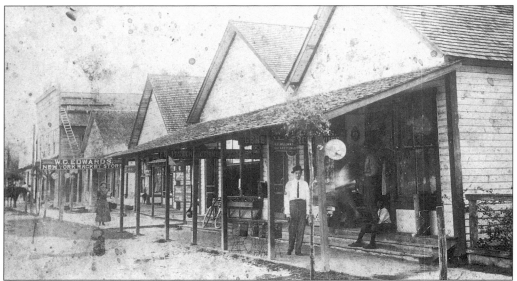

Visitors and residents alike found plenty of places to spend their money in Crystal River in 1910. The town offered 11 mercantile establishments doing nearly $250,000 in annual business. The Boston Dry Goods Store provided keen competition for The Racket Store, operated by Walter and Henry Edwards. Offering everything from soup to nuts, as well as free delivery, advertising for Sparkman Brothers' Store vowed, "We will not be undersold." Two millinery stores supplied hats and accessories for the ladies, while four barbershops saw to the tonsorial needs of local gentlemen. Confectioners and soft-drink parlors satisfied cravings for sweets, plus provided a social setting. For those seeking a little excitement, a billiards and pool hall was available, while several hotels, including the Strathcona Inn, the Hotel Willis, and the Dixon House, provided accommodations for visitors. (Citrus County Historical Society.)

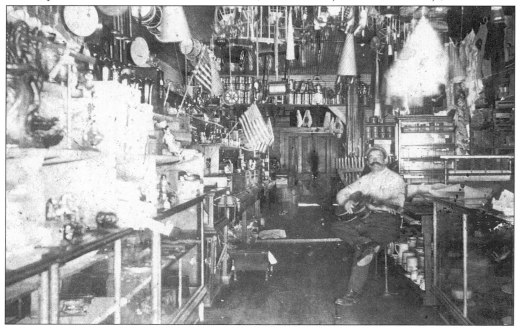

James Ernest Brown worked for the Carlton Hunt family, owners of a Crystal River crate factory. Brown's portrait, dating from 1915, was lost for several years after a company restored the image and then closed its business before returning the photograph. Through the efforts of the *Citrus County Chronicle* and the Citrus County Historical Society, Brown's photograph was finally returned to his family. (Citrus County Historical Society.)

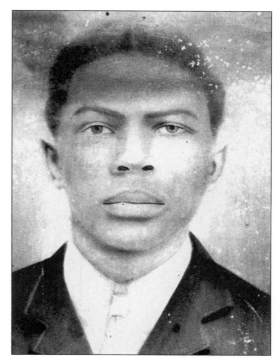

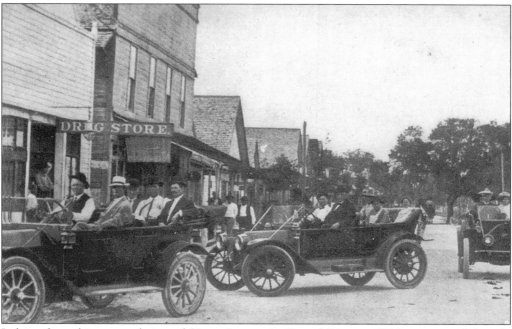

Judging from this postcard view of Citrus Avenue in Crystal River, *c.* 1926, cars were definitely part of the local scene. Although a horse can still be seen in the background, this portion of the business district is the site of a veritable automotive traffic jam. With three, four, and five people in each vehicle, everyone appears to be going for a ride or at least being photographed in their automobile. (Citrus County Historical Society.)

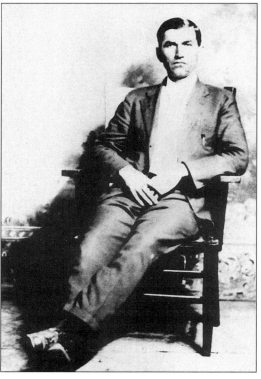

Not everyone was famous or involved in events of great significance. Daily life wasn't always exciting. Most people led ordinary existences, quietly contributing to the fabric of their communities as they earned their wages and reared their families. According to information supplied with these two photographs, William Henry "Bill" Cribb met Lillie G. Schwendeman while both were working at Crystal River's cedar mill. They fell in love, were married by the pastor of the Methodist Church, and went on to raise a daughter, Lillian G. Cribb. Bill once made a trip to California to bring back a formula for making cedar oil at the mill. He and his brother helped to wire the power plant that brought electricity to Crystal River and also helped to build both the school and the jail. An expert seamstress, Lillie was said to have the ability to duplicate any garment from just a photograph or description, never needing a pattern to follow. Just like countless others in towns large and small, they were still an important part of local history. (Citrus County Historical Society.)

Three
BUILDING COMMUNITIES

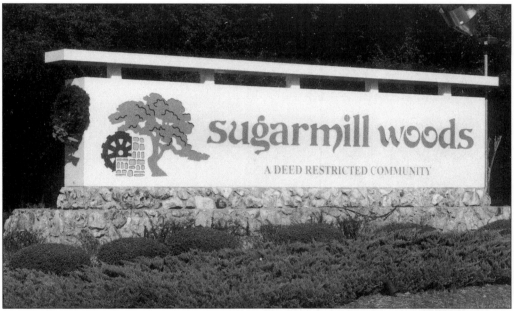

Today Citrus County is growing faster than ever before. In 1970 the county's population numbered only 20,000 people; by 2010, more than one-quarter million residents are expected to call the area home. Relatively inexpensive land for home sites drew many retirees during the 1950s and 1960s; an improved network of highways connecting the county to metropolitan cities further south will make the area a popular bedroom community for commuters in the near future. Differing from the establishment of towns in the 1800s, the trend in recent years has been toward planned communities, such as Citrus Hills, Cypress Village, Sugarmill Woods, and many others. Often built by a corporate entity, developments frequently include not just homes, but also community centers, churches, shopping complexes, medical facilities, and last but certainly not least, golf courses. Several even publish their own local newspaper. (Authors' Collection.)

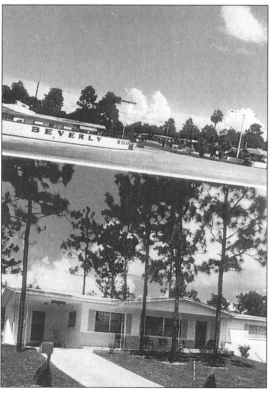

Located in the rolling hills of central Citrus County, Beverly Hills began in 1959 as "Florida's Retirement Hometown." Designed to attract residents from across the nation, postcards advertising the planned community promised, "Life Begins at 40 in BEVERLY HILLS." Amenities included paved streets, a central water system, churches, shopping, stocked lakes, and a community center. With 10,000 home sites today, Beverly Hills also offers its own recreation center and library. (Citrus County Historical Society.)

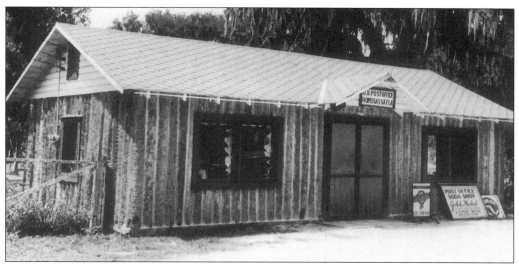

During the late 19th and early 20th century, communities weren't formed as packaged entities, but rather developed gradually. Frequently a particular industry in that locale became the reason behind the birth of a town as workers chose to live near their place of employment. In other cases, optimal growing conditions might make a particular spot a prime agricultural site. One sure sign that a town had been established was the designation of a post office. This log cabin served as Homosassa's post office from 1913 until 1969. (Citrus County Historical Society.)

With a resident population of 50 plus 1,000 newcomers employed by the phosphate mines, the town of Hartshorn received approval for a post office on November 30, 1895. Two years later, the community was renamed Cordeal. Finally, on May 17, 1901, the name Holder was officially adopted. Although the post office has been housed in several different buildings, on January 20, 1947, postmistress Mae Jennings was photographed in front of what was then the Holder post office. (Citrus County Historical Society.)

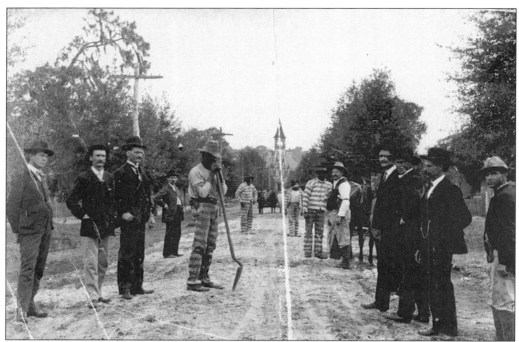

Individuals, institutions, and other factors all combine to bring about the development of a community. The economic viability of an area has always been dependent upon an adequate transportation network. Both residents and visitors must be able to get to their destinations. In order for products to reach consumers in a timely fashion, good roads are essential. In the 1890s, prisoners were used as laborers to improve the streets in downtown Inverness. In April 1935, the Federal Emergency Relief Administration hired many men who were unemployed because of the Depression to build roads in the county. (Citrus County Historical Society and Florida State Archives.)

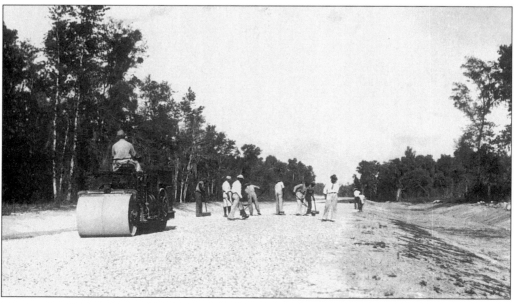

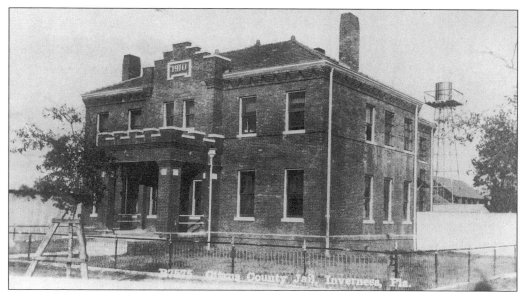

The "good old days" had its share of criminals, as evidenced by this photograph of the Citrus County jail. Constructed in 1910 across the street from the courthouse, the jail provided living quarters and offices for the sheriff. It also included cells for both male and female prisoners, a cell for juveniles as well as one for the insane, and a cell for prisoners in need of hospitalization. Double brick walls provided a deterrent against escapes, as did the gallows housed on the second floor. (Citrus County Historical Society.)

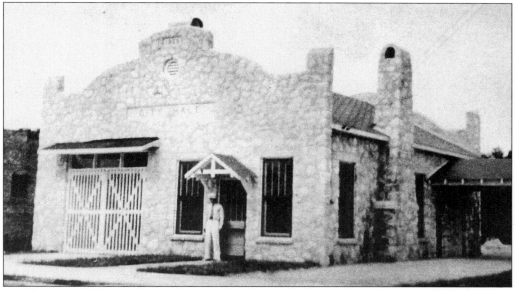

Another step in the process of building communities was the formalization of local government. Used today as the Citrus County Historical Society's Coastal Heritage Museum, a limerock building at 532 Citrus Avenue in Crystal River served as the first permanent Crystal River City Hall. Erected in 1939 by the Works Progress Administration, the structure housed administrative offices, the jail, and the community's fire department. (Citrus County Historical Society.)

For many residents, the establishment of a church was of paramount importance, serving both social as well as religious purposes. Until a building was constructed, services were held outdoors or in private homes. Even after a building was erected, services were frequently non-denominational. New Hope Methodist Church was built in 1886, replacing a log house previously used for services. Much of that lumber, as well as the interior furnishings, were incorporated into the present structure. (Citrus County Historical Society.)

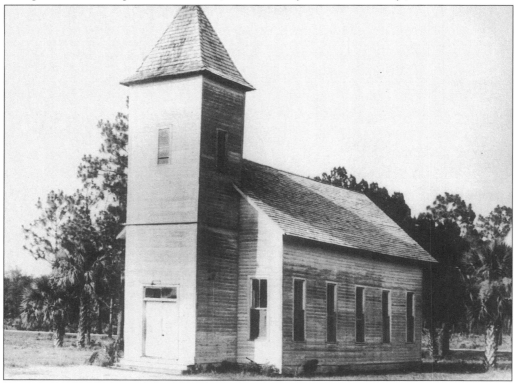

Forty-six men and women who had originally been members of the Crystal River Baptist Church founded the Red Level Baptist Church in 1894. Used by the congregation until 1953, the first church cost $1,000 to build. One member recalled, "It was a struggle to build, but we kept before us the motto, 'Where there is a will, there is a way.' " (Citrus County Historical Society.)

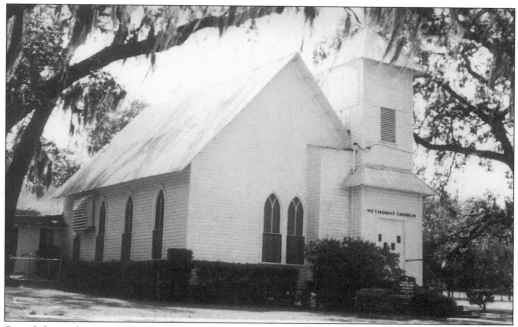

Saved from the wrecking ball, the Floral City United Methodist Church was named to the National Register of Historic Places in 1994. Originally called the Floral City Mission Church, the congregation consisted of only 38 members two years after the church's construction in 1884. As was true in many churches of the era, initially services were led once a month by a traveling preacher until a permanent minister could be obtained. (Citrus County Historical Society.)

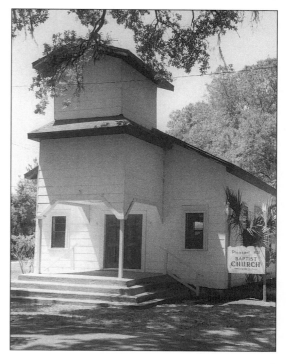

More than 95 percent of the phosphate miners in Floral City were African Americans. Built sometime between 1895 and 1910, the Pleasant Hill Baptist Church on East Magnolia Street is Floral City's oldest religious building for African-American residents. The Folk-style structure is still used as a church and is listed as a site on the Florida Black Heritage Trail. (Authors' Collection.)

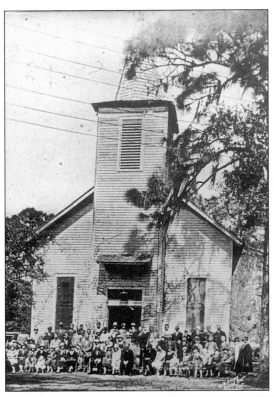

Although this building has often been identified as the original Presbyterian Church in Crystal River, it is actually the second, a fire in 1924 having destroyed the first church. Beginning in 1883 with Bible readings and gospel singing held in a tent, the congregation formally organized in 1885 under the auspices of the Presbyterian Church of the United States. The membership continued to meet in tents, private homes, and stores until the church building was completed in 1889. (Citrus County Historical Society.)

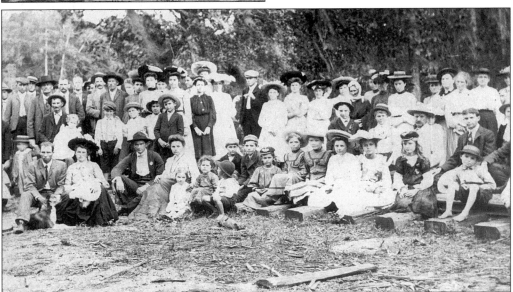

Religious activities were not always officially organized nor were they invariably held indoors. A number of Lecanto residents, including the Allen, King, Barnes, and Davis families, met for a baptizing ceremony and dinner at Homosassa Springs in 1903. Proper attire for the occasion was obviously more formal than that worn to outdoor functions today. (Citrus County Historical Society.)

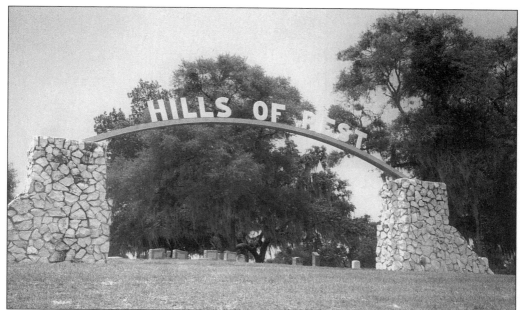

Life was hard in the 1800s—the modern medical advances leading to the greater longevity experienced today had not yet occurred. The establishment of burial grounds took place, in many instances, even before churches were officially organized. Cemeteries are scattered throughout the county, varying in size from those covering many acres to just a few isolated headstones. The Hills of Rest Cemetery, one of the more elaborate burial grounds, sits on a bluff just outside of Floral City and was established by Daniel Pheil in 1884. Both he and his wife are buried there. Far less formal is the Stage Pond Cemetery. Its tall pines and weathered tombstones are just about all that remain of the once thriving community of Stage Pond. (Authors' Collection.)

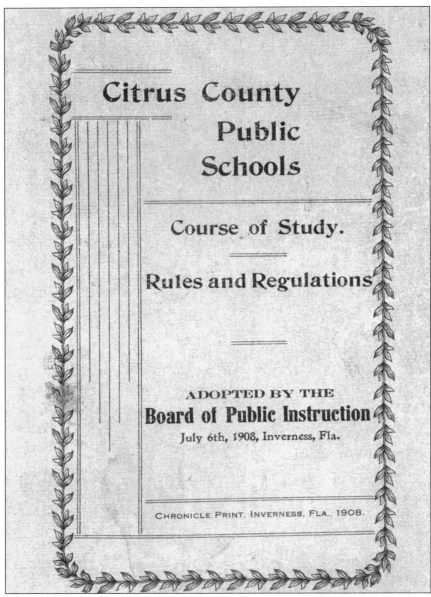

Citrus County
Public
Schools

Course of Study.

Rules and Regulations

ADOPTED BY THE
Board of Public Instruction
July 6th, 1908, Inverness, Fla.

CHRONICLE PRINT. INVERNESS. FLA., 1908.

Local schools were essential for every community that hoped to produce educated young people as its future citizens. By 1908, the Board of Public Instruction had published a booklet delineating the course of study, rules, and regulations for all Citrus County public schools. Presently housed in the archives of the Citrus County Historical Society, the booklet provides a detailed look at the state of education in the county at the beginning of the 20th century. "A school day shall comprise not less than six hours exclusive of recesses." Books furnished by the county were to be returned in good condition at the end of the school term. An average grade of 75 in all courses, with no grades falling below 50, was required for promotion to the next class level. Pupils were also forbidden to bring to school "a dog, pistol, gun, bow and arrow, sling shot, or other weapon by which pupils or others might be injured." Chewing gum and smoking tobacco were also prohibited. (Citrus County Historical Society.)

As would all pupils in the county, students attending junior high school in Floral City in 1908 would have received a holiday vacation that extended from December 23rd until January 2nd of the following year. Teachers were admonished that they would receive no salary from public funds for any teaching completed during that period. (Citrus County Historical Society.)

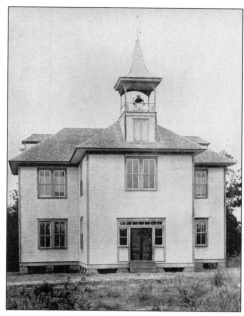

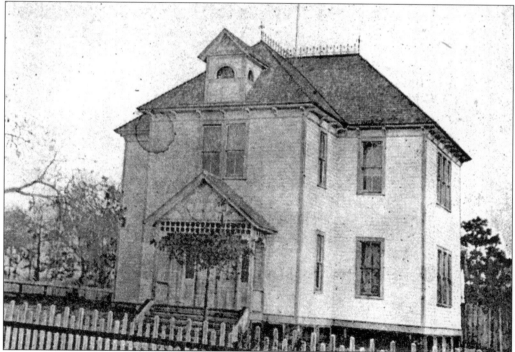

It was suggested that all pupils, including those at the rural graded school in Crystal River, begin their school day at 8:30 a.m. with general exercises, followed by classes in "number work and arithmetic, reading and grammar, and algebra." After a noon-hour break, studies of "chart, spelling, and geography" would be followed by "writing and drawing, plus chart and physiology." The day would end at 4 p.m. after classes in history and drill had been completed. (Citrus County Historical Society.)

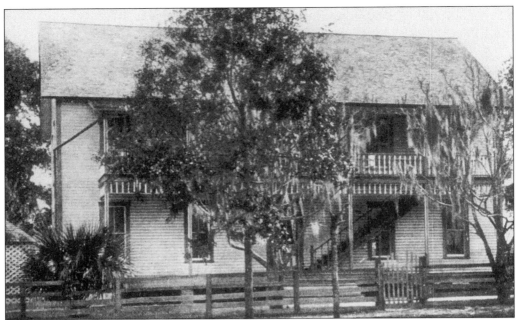

Pictured on a postcard mailed in 1908, the two-story wood frame Citrus County High School in Inverness resembled many of the other lower-level schools scattered in towns throughout the county. It was just a little larger. Things were soon to change, however. A postcard dating from just five years later shows the new Citrus County High School, a modern building of considerably enhanced size. The rules hadn't changed, however. Pupils were still required "to attend school punctually and regularly; to conform to all rules of the school; to obey all directions of teachers; to observe good order and deportment; to be diligent in study, respectful in manners, kind, and obliging to schoolmates, and to refrain from the use of profane or improper language." (Citrus County Historical Society.)

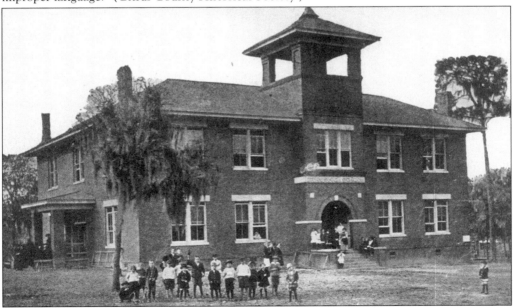

While the rules might stay the same, there were some changes over the years. Mamie McAleer, a teacher at Lecanto school in 1880, appeared to epitomize proper attire and deportment. Katy Lashley, a teacher at the Ozello school, appeared far more practically dressed for her job. Located on an island in the St. Martins River since 1880, the school had at peak attendance as many as 52 pupils, all of whom had to travel to school by boat. Prior to its closing in 1943, the Ozello school was featured in Ripley's "Believe It Or Not" as "The Isle of Knowledge." (Citrus County Historical Society.)

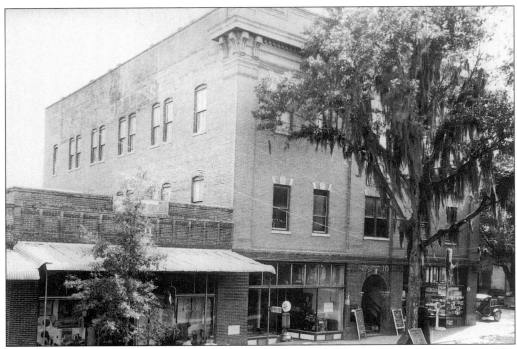

Organizations, civic and fraternal, also had a part in the building of communities. The groundbreaking ceremony for the Masonic Temple in Inverness was attended by hundreds of people in 1910. The tallest building in town at the time, the brick structure cost more than $18,000 to build. Used not just by the Masons of Lodge No. 18, the Masonic Temple was the scene of many community activities, including theatrical performances and movies. (Citrus County Historical Society.)

The site of many local activities for more than 60 years, the Floral City Community Building was built in 1936 as a Works Progress Administration project under the supervision of local builder John Ogden. The construction not only provided jobs for residents left unemployed by the Great Depression; it also utilized as a building material limestone rocks collected from defunct phosphate mines nearby. (Citrus County Historical Society.)

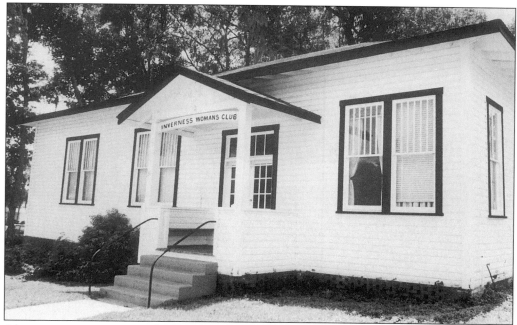

Almost every community of any size had organizations such as the Women's Club, Kiwanis, American Legion, 4-H, Red Cross, and others that performed a variety of civic and social service functions. In Inverness, the membership of the Women's Club was especially fortunate to have its own building. Constructed in 1922 and incorporating portions of an earlier structure, the building at 307 West Main Street provided a meeting place not just for the ladies, but for other community organizations as well. For example, members of the Kiwanis Club were photographed during Charter Day ceremonies at the Inverness Women's Club in the spring of 1925. (Citrus County Historical Society.)

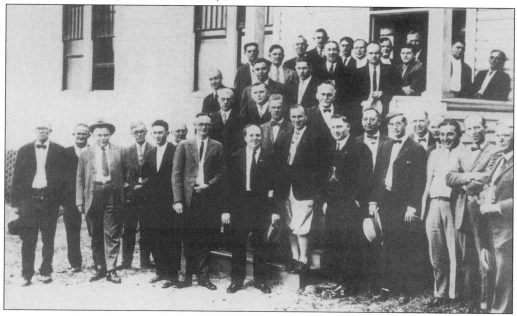

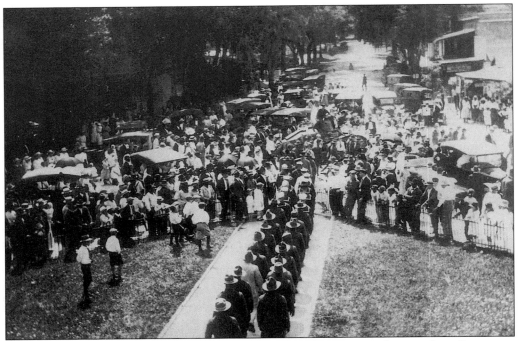

Communities large and small across Citrus County sent their young men off to war in 1917 and again in 1941, as America entered World War I and World War II. The same patriotic fervor prevailed during subsequent military actions in Korea, Southeast Asia, and the Persian Gulf. The courthouse in Inverness was often the scene of ceremonies honoring veterans, either as they departed or upon their return from service. (Citrus County Historical Society.)

Thirty-one Citrus County residents gave their lives for their country during World War II. Eugene Quinn of Inverness, a member of the 16th Bombardment Squadron stationed in the Philippines, did not survive his capture as a Japanese prisoner of war. Today several granite monuments in front of the old courthouse pay homage to the military contributions of county residents. (Citrus County Historical Society.)

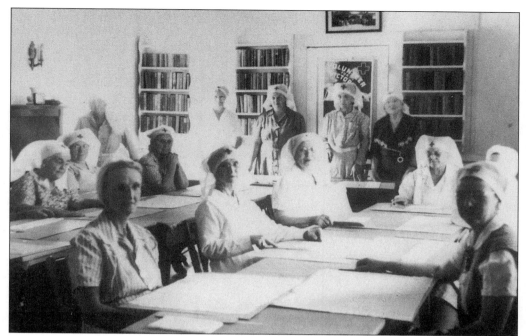

Women made many contributions to the war effort as well. These members of the Crystal River Women's Club served as Red Cross volunteers. Frances Langford, the beautiful singer and entertainer, was another Citrus County resident who did her part performing for the troops at USO shows around the world. Langford's father was working for one of the phosphate companies in Hernando when his daughter was born in 1914. (Citrus County Historical Society.)

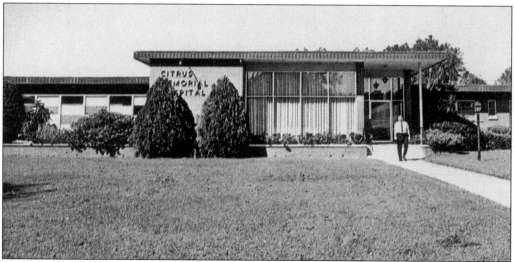

As a result of community activism on the part of both individuals and organizations such as the Kiwanis Club, the Citrus Memorial Hospital opened its doors on July 11, 1957. Built at a cost of more than $400,000 in public and private funds, the 17,000-square-foot, 30-bed hospital was the county's first. Prior to its construction, patients in need of hospitalization had to travel to adjacent counties for medical care. (Citrus County Historical Society.)

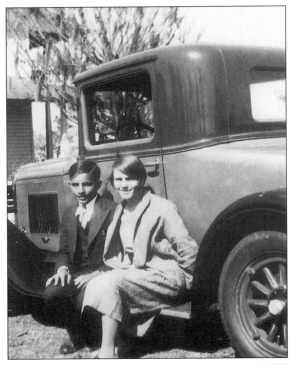

A final component to the building of communities is the task of documenting and preserving the history of the area. While Citrus County is fortunate to have both individuals and organizations that have worked tirelessly to accomplish this, two individuals merit special mention. Son of a Floral City phosphate mine superintendent, Hampton Dunn (pictured with his twin sister, Hazel, in 1929) spent many years as a newspaper reporter for the *Tampa Daily Times*. In writing *Back Home, A History of Citrus County, Florida*, a nearly 500-page book published in 1976 by the Citrus County Bicentennial Steering Committee, Dunn incorporated the photographs and recollections of many long-time residents. Mary Isabel MacRae arrived in Homosassa with her husband James in 1914 and spent the rest of her life working to preserve the historic and natural resources of Citrus County. Founder of the Citrus County Historical Commission and Society in 1963, she led efforts to preserve the Yulee Sugar Mill and other significant areas. She also authored *Citrus County Historical Notes*, first published in 1976 by the Homosassa Library Board. (Citrus County Historical Society.)

Four

AT WORK

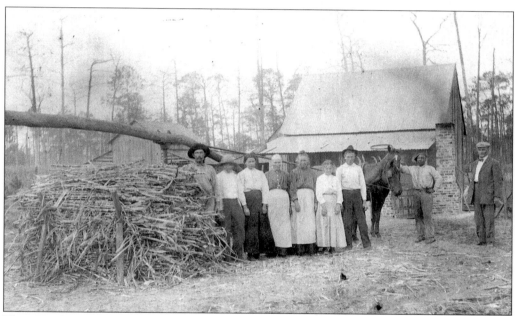

The 1900 Citrus County census boasted 5,391 residents, most of whom were engaged in farming of some type, whether small truck farms or large farms of hundreds of acres. Pictured in the early 1900s during sugar cane processing are the Levins and the Sheffields at the Levins' farm in Red Level. Citrus Countians took great pride in recalling that in the years following the Civil War, a government publication stated that with regard to its quality for farming, the land was "worthless, being nothing more than a bed of sand that would not produce anything." Nevertheless, crops were bountiful in Citrus County. Farmers raised potatoes, corn, sugar cane, rice, hay, cabbage, peanuts, tomatoes, watermelons, beets, grapes, and beans. Sugar cane production was unparalleled, with canes reaching 28 to 30 joints. Most property owners also raised a few citrus trees. With cheap land, a good transportation network, and year-round good weather, farmers produced record crops. (Citrus County Historical Society.)

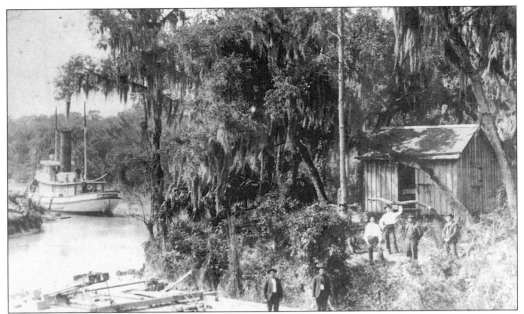

This photograph of the *John L. Inglis* preparing to enter the Orange State Canal at Floral City illustrated part of that transportation network. The Florida Orange Canal and Transit Company constructed the five-mile-long canal in 1884 to link Floral City farms with the railroad at Lake Panasoffkee. Several paddle-wheeled steamboats, including the *John L. Inglis*, regularly transported produce, until the extension of the railroad in 1893 and the freeze of 1895 led to the demise of the steamboats. (Citrus County Historical Society.)

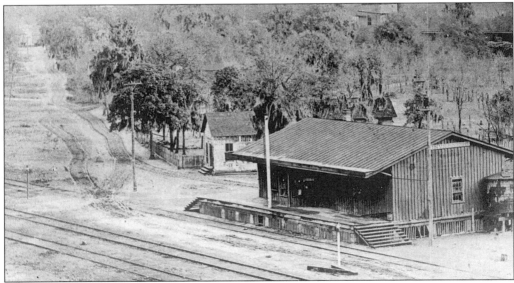

Few innovations offered as much to Citrus County as did the railroad. By the close of the 19th century, the railroad line extended throughout the county, including stops in Hernando, Istachatta, Floral City, Crystal River, and as pictured, Inverness. Formerly dependent upon steamships or wagons, Citrus County residents were now able to ship their goods in less time as well as to travel in relative speed and comfort. (Citrus County Historical Society.)

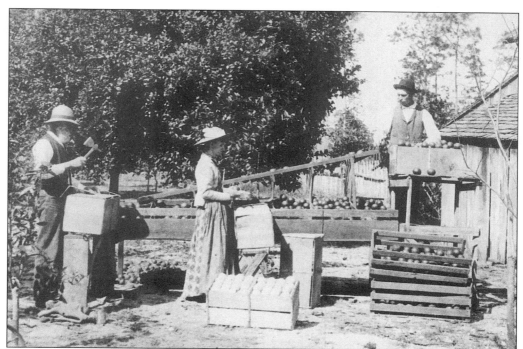

Oranges were an important cash crop to the landowners of Citrus County; anyone with land planted at least a few trees or if possible, large groves. The importance of citrus to the Sunshine State can hardly be overstated, providing Florida a major industry as well as its state flower. With regard to Citrus County, the industry not only gave the county its name—a prominent local resident, David Yulee, developed the Homosassa orange, a variety still grown today. (Florida State Archives.)

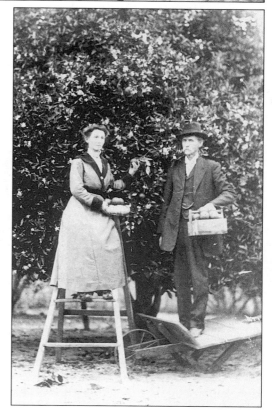

The Reverend J.D. Lewis, pastor of the Cumberland Presbyterian Church, and his wife posed for a photographer while picking oranges. Believed to have been introduced to Florida by Spanish explorers in the 16th century and spread throughout the area by Native Americans, thriving orange trees were discovered by the first settlers. These untended trees became the foundation for the commercial citrus industry. (Citrus County Historical Society.)

As did other Citrus Countians, R.O. Hicks maintained an orange grove in addition to his other entrepreneurial interests. Following his arrival in 1886, Hicks operated a steamboat in the Inverness area transporting fruits and vegetables on the Withlacoochee River. The freeze of 1895 had a devastating effect on his business, forcing the sale of the steamboat, although the groves continued to be operated by the family. (Citrus County Historical Society.)

Early settlers believed that the region was immune to severe frosts that would damage citrus crops. They soon found out otherwise, when the "Big Freeze of 1895" wiped out most of the groves. While some growers replanted, citrus as a major industry never really made a comeback in the county. Devastating freezes continued to occur periodically. The freeze of 1962, captured in this photograph of groves at Hicks Point, was described as the "worst cold wave of the century." (Citrus County Historical Society.)

The consummate promoter when it came to his oranges, "Doc" Ferris of Ferris Groves is pictured handing some of his "World's Finest Fruit" to Sharon Conrad in June 1962. Doc owed much of his success to the foresight of his father, James C. Ferris. With the intention of developing the property, the senior Ferris had purchased several hundred acres in Floral City just after land values crashed in 1926–1927. (Florida State Archives.)

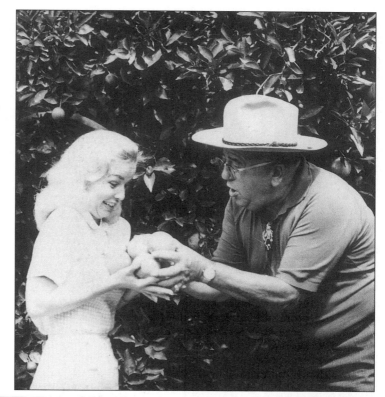

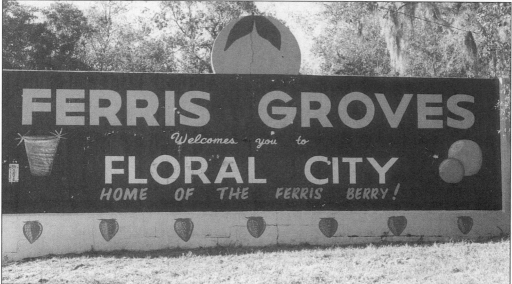

Although James Ferris's development dreams were never realized, L.G. "Doc" Ferris seized the opportunity and planted more than 36,000 citrus trees, producing oranges described by entertainer Arthur Godfrey as "the finest I ever tasted." Following another freeze in 1985, Ferris Groves diversified, planting 50 acres of strawberry plants. Today signs on the outskirts of Floral City welcome visitors to the "Home of the Ferris Berry." (Authors' Collection.)

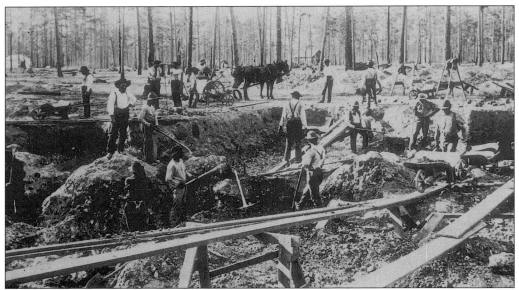

Both the economy and the landscape of Citrus County underwent a major change soon after rich deposits of phosphate were discovered on May 1, 1889, in nearby Dunnellon. When Albertus Vogt's handyman found some fossilized teeth and bones, Vogt realized their significance and had rock samples tested. After the tests confirmed the presence of high quality phosphate, Vogt and Ocala financier and land agent John Dunn began buying up local property. (Florida State Archives.)

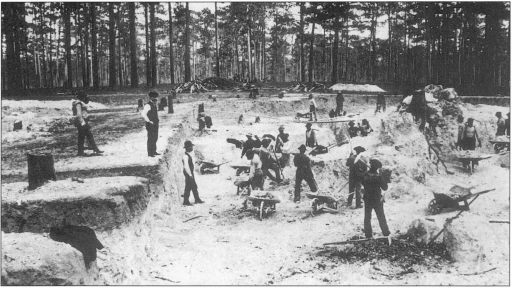

While the phosphate business thrived, land sold for fortunes. Thousands of men came to Citrus County to work in the mines. A visitor to the area in December 1889 wrote, "The hotel was crowded to overflowing with speculators, and workmen were boring and opening the hills exposing large beds of matter supposed to be rich in phosphates." The boom spread quickly, with mines soon operating in Hernando, Floral City, Holder, and Inverness. (Florida State Archives.)

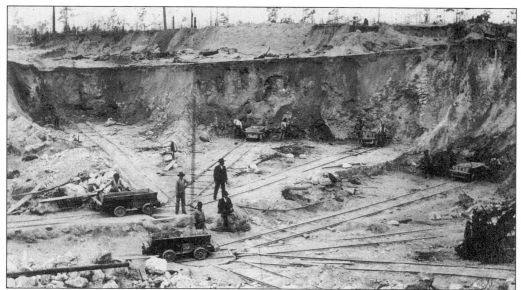

At the height of the phosphate boom, Floral City's mines employed nearly 10,000 people who performed backbreaking work. In the early days, the men wielded picks and shovels, digging out the phosphate. Boulders were broken into manageable pieces. Wheelbarrows, otherwise known as Georgia buggies, were filled and pushed up the slopes to wagons. Rock was then crushed, washed, and loaded onto railroad cars. By 1910, there were 34 phosphate plants in operation, employing thousands of workers in Citrus County. (Citrus County Historical Society.)

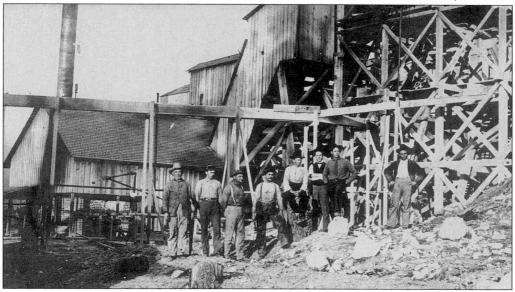

The opening of the mines caused an influx of workers, most of whom were African-American men. Boom days would continue until the onset of World War I brought an end to business with European markets. Citrus County would never really recover its share of the lucrative although dangerous industry. One miner recalled, "Sometimes the walls would cave in killing five to six men at a time. It would take two or three days to dig them out." (Citrus County Historical Society.)

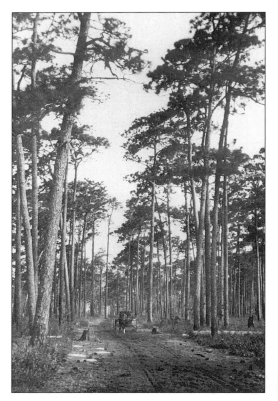

The Detroit Post Card Company recorded this image of Florida's pine woods in 1904. The large stands of cedar, pine, oak, and cypress trees in Citrus County had always been important. Early pioneers found a ready supply of timber necessary for that most basic of needs—construction of a cabin to keep out the elements and wild animals. As the area was settled, almost every town, large and small, boasted a sawmill. (Library of Congress.)

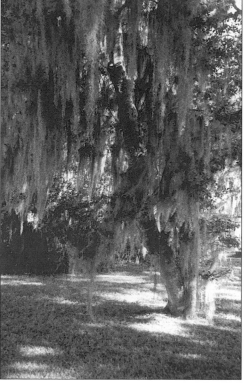

Strands of Spanish moss festooning tree branches in Citrus County provided a source of income for many residents, especially during the 1920s and 1930s. After being pulled from the trees, soaked to remove the outer covering, dried, and cleaned, the moss was sent to factories that used it as stuffing for mattresses, furniture, and seat cushions. Picking one ton of moss per day could net a family as much as $30—a bountiful sum during hard times. (Authors' Collection.)

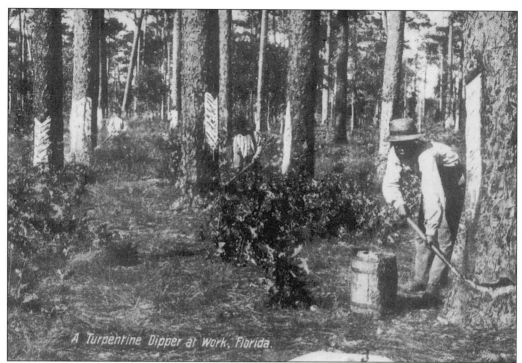

A Turpentine Dipper at Work, Florida.

With its vast acreage of pine forests, Citrus County was an ideal home for the turpentine industry. As captured in this photograph, workers first cut the tree near the ground with a boxing ax; the sap would then flow into boxes or clay cups. Following collection and distillation, the turpentine was stored in barrels for shipment. In the 1890s, a 320-gallon barrel of turpentine brought around $3. (Florida State Archives.)

Turpentine, an important ingredient in varnish, paint, soap, explosives, ointments, and even medicines, was a big business. Employers provided Spartan living accommodations to house laborers brought in to work in both the forests and the distilleries. In addition, many of the men were paid not with currency, but rather with tokens or script that could be redeemed for purchases at company commissaries. This former turpentine still commissary is located on Highway 480. (Authors' Collection.)

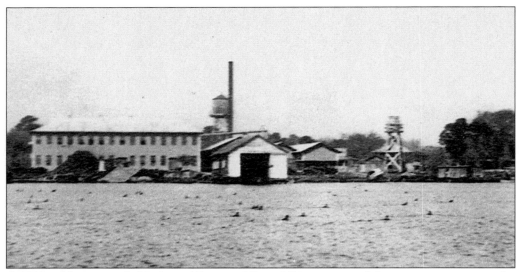

A 1910 publication titled *Industrial Review of Crystal River* promoted the community, its people, and its industries. It cited as prominent among the local manufacturing plants the "Cedar Mill of the Joseph Dixon Crucible Company, which has been in constant operation for the past 27 years, with its hundreds of employees engaged in the gathering of cedar logs and their manufacture into stock for 'Dixon's Pencils.'" (Citrus County Historical Society.)

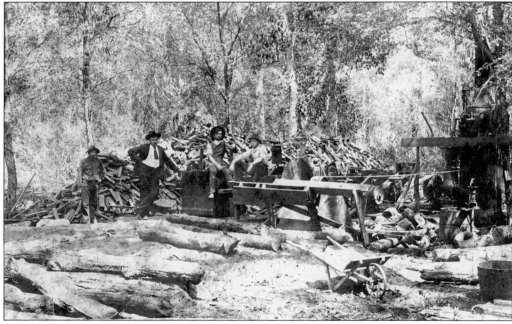

Lumber was cut and gathered by contract labor deep in the forests. Dragged to the rivers and streams by oxen, the logs floated to the Gulf of Mexico and were then towed to the plant in Crystal River. The Dixon pencil factory listed many African-American men on its employee rolls. The reason was purely pragmatic—it was believed that blacks were better able to resist malaria and other diseases than were whites. Workers were recruited from as far away as Cuba. (Citrus County Historical Society.)

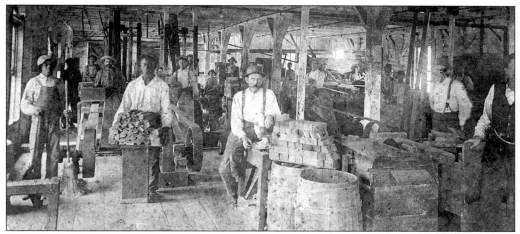

The interior of a cedar mill was a hubbub of activity. Once at the mill, the logs were cut into pencil-sized slats and packed for shipment. From the Dixon Company rail siding they were sent to the Crystal River rail station and then on to New Jersey for completion. Leaded, split, and painted a shiny yellow, the logs completed their transformation into pencils. (Citrus County Historical Society.)

The large lumbering enterprises were very much closed operations. Although some workers were local residents, many were imported from other areas. Wages were considered high, but much of the money paid to employees returned to the owners in the form of rent for company-provided housing situated on company land or for purchases from company-owned commissaries. The situation was quite lucrative, at least for the companies, until the timber began to run out. (Citrus County Historical Society.)

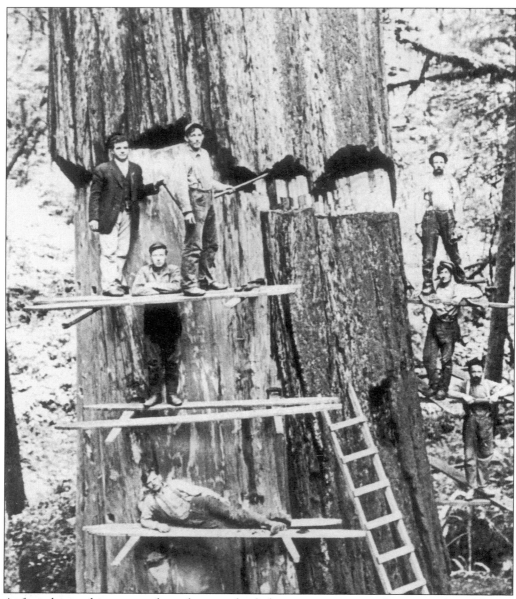

At first glance, this seems to be a photograph of a logging operation in the giant redwood forests of California. Not so! These rugged lumbermen were taking a brief respite from their attack on a bald cypress tree somewhere in Citrus County around the turn of the 20th century. While little is known of the story behind the photograph, it has been estimated that the tree was several thousand years old, with a circumference at the base of approximately 50 feet. The crew would attach springboards to the tree, allowing them to work high above the thickened base. In addition, because the saws commonly used were only 12 feet long, it was necessary to notch through several outer layers of the tree before starting the crosswise cut. A tree of this size, potentially 100 to 125 feet tall, would have required most of two days for the men to fell. Even so, cutting down the tree was often easier than getting it out of the swamp or woods. (Citrus County Historical Society.)

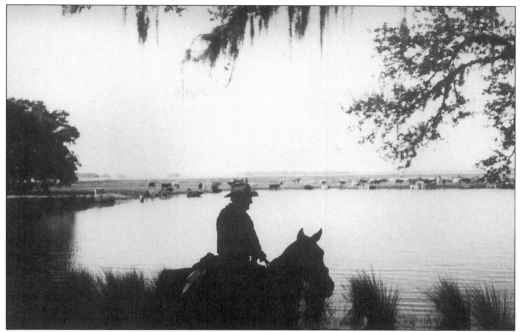

Sixteenth-century Spanish explorers are credited with the introduction of cattle to Florida. The descendants of those animals, the scrub cattle found on the open range of Citrus County in the late 1800s and early 1900s, had undergone few changes over the years. At the same time, the area's open-range cattle country of the period was as wild and rough as any to be found in west Texas. Ranchers were faced with the hardships of mosquitoes, rustlers, and range wars. (Citrus County Historical Society.)

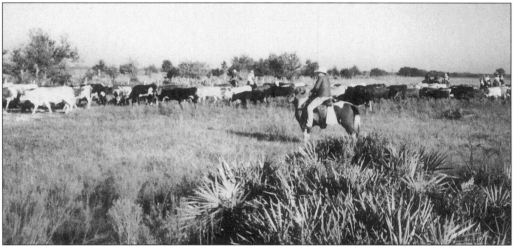

Florida's cattlemen were frequently known not as cowboys, but as cowhunters, since the cattle had to be hunted down in the woods. Many believe that the term "crackers," often used to describe rural Floridians, was derived from the cracking sound made by the whips the cowhunters carried. Rooks, Bellamy, Priest, Croft, Van Ness, Jones, and Townsend were all names that would be included on any list of well-known cattle ranchers in Citrus County. (Citrus County Historical Society.)

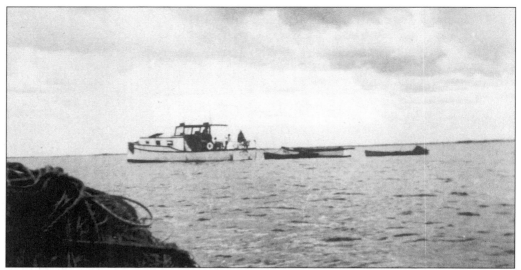

Fishing as a major industry flourished in Citrus County following the Civil War. By the days of the Great Depression, the area boasted nearly 100 commercial fishermen, catching sea trout and mullet, as well as large quantities of oysters, crabs, and shrimp. The area still continues to be a fisherman's paradise, although its days as a commercial fishing center have diminished considerably. (Citrus County Historical Society.)

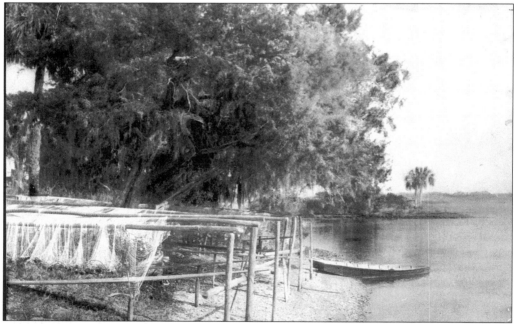

At the end of the day, mullet nets were hung out to dry and be repaired. Speckled perch, bass, catfish, bream, mullet, sea trout, grouper, mackerel, shad, pompano, redfish, and snapper were but a few of the varieties of fresh and saltwater fish to be found. Recognizing the abundance of fish, Native Americans christened one of the county's largest inland bodies of water as Lake Tsala Apopka, a name that translated as the "lake where trout are eaten." (Citrus County Historical Society.)

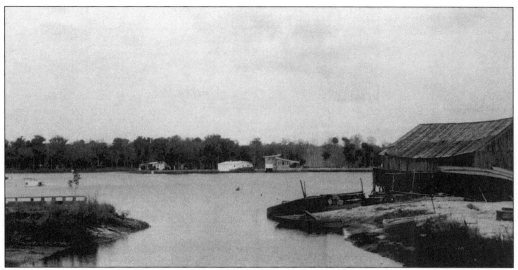

In the early 1900s, oyster canning factories, as well as a number of wholesale fish houses that shipped carloads of fish each week, were located in Crystal River. L.C. Yeoman's Miller's Point Fish Company, pictured here in 1925, advertised "Fresh oysters received daily from the Gulf." (Citrus County Historical Society.)

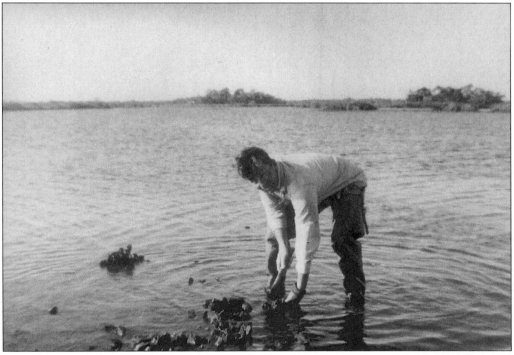

Several local fish dealers, including the Crystal Fish and Oyster Company and the Gulf Fish and Oyster Company, boasted of their use of the "VAC-JAC" Oyster Carrier and advertised that "Oysters packed in this carrier retain their natural flavor and reach you in perfect condition." For local residents such as this man, as many oysters as one wanted could be had with little effort. (Citrus County Historical Society.)

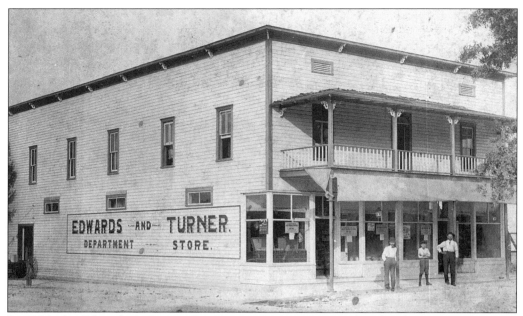

In 1907, the Edwards & Turner Department Store in Hernando offered one-stop shopping, carrying assorted dry goods, groceries, boots, shoes, clothing, and a full line of household furnishings. Standing in front of the store are George D. Edwards, Bill Rutledge, and Ashley Spooner. Commerce in this particular building came to an end when a massive fire destroyed the structure. (Citrus County Historical Society.)

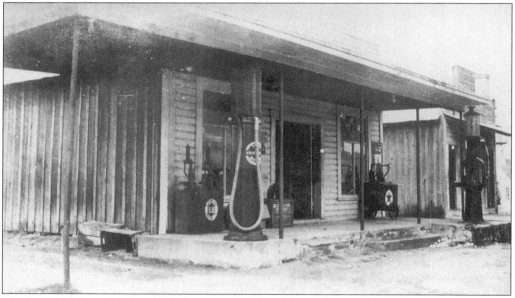

The James T. Love family of Floral City certainly exhibited an entrepreneurial spirit. Love and his wife, Stella, owned and operated several businesses including a grocery store, a meat market, a drug store, and a citrus packing house. Displaying a sign of the changing times, the Love Grocery Store featured a shiny new gas pump to meet the fuel needs of automobile owners in the area. (Citrus County Historical Society.)

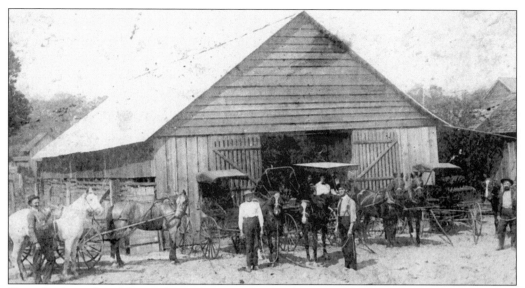

Cars slowly replaced horse-drawn buggies, forcing livery stable owners to either go out of business or convert their stables to other enterprises. In 1907–1908, despite an auto registration fee of only $2, only one automobile was registered to a Citrus Countian. Coincidentally, W.H. Boswell of Hernando just happened to be an automobile dealer. (Citrus County Historical Society.)

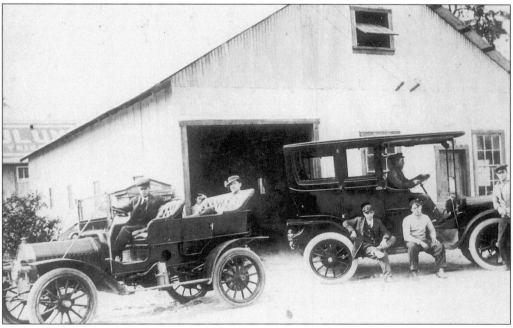

The roads in the county were usually primitive—hard-packed sandy ruts through the countryside. In 1909, W.H. Boswell offered the county an interest-free loan to begin an aggressive road-building program. The county quickly accepted his offer. The improved roadways must have certainly helped to stimulate interest in automobiles, which Boswell was happy to sell from his Inverness car dealership. (Citrus County Historical Society.)

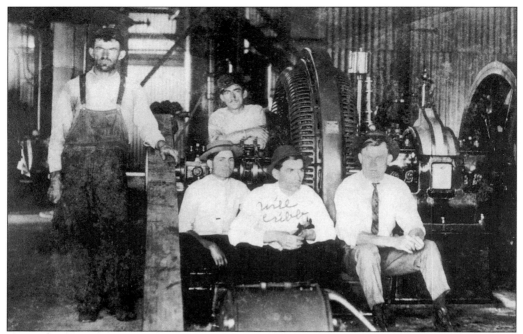

The phosphate boom in Citrus County brought more than money and an influx of workers. Needing electricity for its mines, the Camp Phosphate Company erected a power plant on the Withlacoochee River in 1907–1908. A number of towns soon subscribed to the service in order to receive electricity. The new Florida Power plant in Inglis, completed in 1927, generated sufficient electricity to supply the entire county. (Citrus County Historical Society.)

After years of construction and a cost of over $400 million, Florida Power Corporation's nuclear power plant began operation at 8:42 a.m. on January 14, 1977. Sharing the same designers as the disastrous Three Mile Island facility in Pennsylvania, the Crystal River plant had its critics. Consumer advocate Ralph Nader labeled it "the fourth-worst facility in the country in terms of number of problems." Running smoothly in recent years, the plant remains the area's largest employer. (Authors' Collection.)

Five

At Play

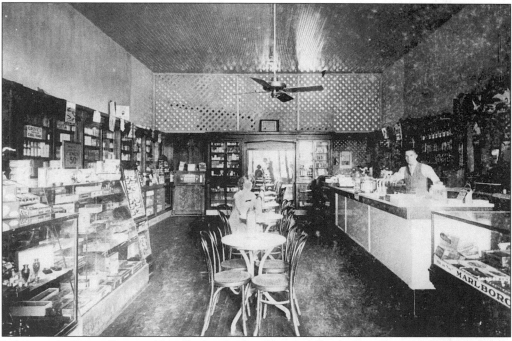

Life in early Citrus County, like all of early Florida, was difficult. People worked hard to earn a not always luxurious living. It wasn't all work, however; there were good times as well. Residents had a variety of ways in which to spend whatever free time they might have. For example, pharmacies such as Hall's Drug Store in downtown Inverness sold more than just medicines and miscellaneous sundries. With the addition of a soda fountain and an ice cream parlor, the drug stores quickly became social centers. Businessmen taking a break from their jobs, women doing their weekly shopping, and even courting couples could spend a few minutes relaxing over a tasty treat. In this photo taken in 1927, Annie Vann is seated at one of the tables. Uncle Earl Vann owned the store at the time. (Citrus County Historical Society.)

The streams, rivers, and lakes of Citrus County were filled with numerous kinds of fish, while the nearby Gulf of Mexico provided an additional resource for anglers. An afternoon spent on the water might offer the chance to explore the twists and turns of local rivers. At the same time, for a fisherman of even minimal skill, the afternoon could provide not just recreation, but dinner as well. Photographed in front of the Orange Hotel in Inverness, the men pictured below proudly displayed their catch. Their clothing is somewhat more formal, however, than that worn by most fishermen today. (Citrus County Historical Society.)

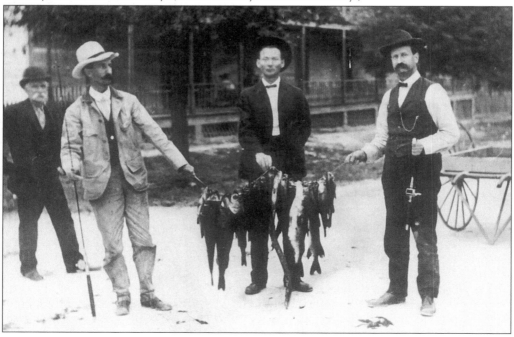

As with fishing, hunting was a form of recreation that also had its practical side. It too could put dinner on the table. The woods of Citrus County abounded with game of all kinds and sizes—deer, bears, wild pigs, turkeys, quail, raccoons, and squirrels. In this photograph taken in 1908, guide Robert L. Thompson and an unidentified woman set out in search of game. The trained hunting dogs, penned in the cage on the back of the wagon, would be released at the scene of the hunt. (Citrus County Historical Society.)

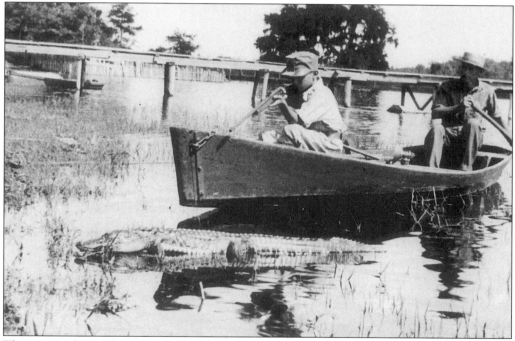

Thirty years later, Ebert Castel and his father were photographed as the younger Castel took aim on an alligator near the old steamboat landing in Floral City. Lake Tsala Apopka, along with the other lakes in the county, was well supplied with alligators that were hunted for sport, meat, and hides that would be sold for use in purses, wallets, and shoes. As excessive hunting reduced the alligator population almost to the point of extinction, laws were introduced restricting their capture. (Citrus County Historical Society.)

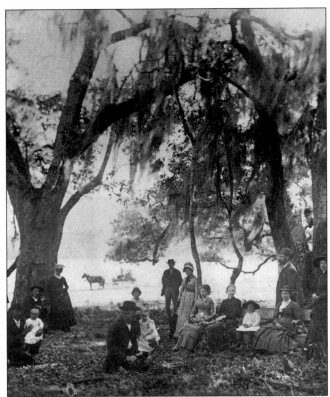

Many people today enjoy packing a basket with food and drink and heading to the beach or the woods for a picnic. The idea isn't a new one, however. Floral City's Lake Consuela was a popular spot for a picnic in 1880, while the folks in the lower photograph enjoyed lunch near Chassahowitzka in 1908. Whether organized by the community, a church, a local civic group, or just a few friends gathering together to share some food, recreation, and conversation in the outdoors, picnics have always been a pleasant way to spend an afternoon. (Citrus County Historical Society.)

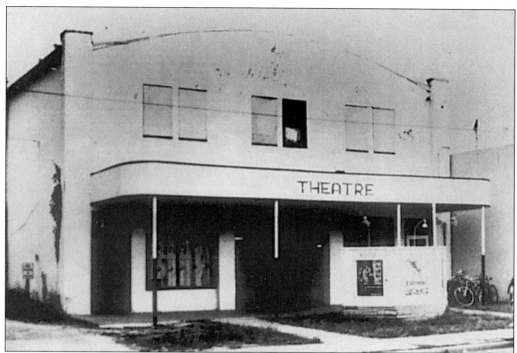

In the early 1920s, the Avalon, owned by Tamiami Enterprise Theatres, Inc., became the first theater in Inverness to install the modern equipment needed to show motion pictures with sound, also known as "talkies." Prior to the construction of individual movie theaters, minstrel shows, Chautauqua lectures, and viewings of silent films had taken place in the auditorium of the Masonic Temple. (Citrus County Historical Society.)

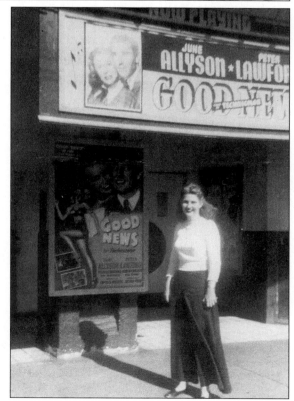

Living in a two-story home just across the street from the courthouse in Inverness, Marjorie Yoder didn't have far to go to see a motion picture featuring popular movie stars of the day such as June Allyson and Peter Lawford. Two local theaters, the Valerie and the Victory, formerly known as the Avalon, were located adjacent to the courthouse square. (Citrus County Historical Society.)

Movies came to Citrus County in December 1931 in a different fashion. The county assumed a starring role as Edward Alexander, director, producer, and head of United Artists, arrived in Homosassa to film the second installment of a 12-part travelog on the native tribes of Africa. Sponsored by the State Motion Picture Committee and filmed at different Florida sites, the venture was intended to impress movie directors in New York and California with the state's merits as a motion picture location. Hundreds of local residents were used as extras, while a few played more significant roles. Newspaper articles encouraged attendance "not only to inject action into the picture, but with the thought that some types may be discovered, and it is not inconceivable that star material may be found. Such things have happened, and history may repeat itself." (Citrus County Historical Society.)

Hollywood returned to the area again in 1961 when portions of *Follow That Dream* were filmed in Citrus County. Based on Richard Powell's novel *Pioneer Go Home* and starring Elvis Presley, the motion picture featured scenes shot in the courthouse at Inverness, on King's Bay, and at Crystal River High School. The courtroom scene from the movie provided important architectural information during the subsequent restoration of the courthouse. (Citrus County Historical Society.)

During filming, "The King" stayed at the Port Paradise Motel in Crystal River. Although a number of local people served as extras in the movie, Pam and Pat Ogles, three-year-old twins from Crystal River, played a single supporting role. Their grandmother was quoted in the local paper as saying, "All they had to do was be brats and they are good at that." They also managed to have their picture taken with Elvis. (Citrus County Historical Society.)

It doesn't require the presence of a Hollywood film crew for people to shed their everyday lives and assume a different role. Floral City Heritage Days take place each December. Activities include a parade complete with Santa Claus riding atop a horse-drawn wagon, tours of notable local homes, musical performances, and reenactments of various historical events. Garbed in the uniforms of the Civil War, these two men have traveled back in time nearly 140 years. No modern motel or even an historic bed-and-breakfast inn for them; their accommodations consist of a canvas tent, complete with a cot, a wooden stool, and a coffeepot over an open fire. (Authors' Collection.)

Helping to spread the word about the Citrus County Historical Society's latest projects are Carol Buckner, the education coordinator for the Old Courthouse Heritage Museum, and her daughters, Ashley and Allison. Period attire, folk music, dancing, delicious country foods, antique cars, tractors, and high-wheeled bicycles all add to the historical flavor of the event. (Authors' Collection.)

Craftsmen come from across the state to participate in Floral City Heritage Days. Demonstrating the proper technique for turning a piece of wood on a foot-powered lathe is Fritz Wilder, a St. Petersburg resident. Other folk art presentations include cow whip making, printing, basketry, weaving, woodworking, pine needle work, and chair caning. (Authors' Collection.)

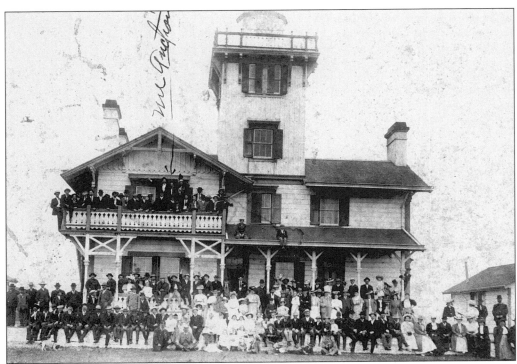

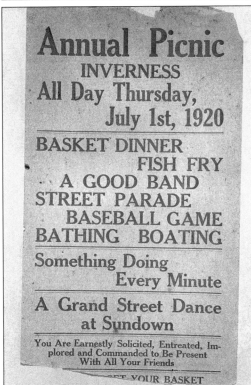

Annual Picnic
INVERNESS
All Day Thursday,
July 1st, 1920

BASKET DINNER
FISH FRY
A GOOD BAND
STREET PARADE
BASEBALL GAME
BATHING BOATING

Something Doing
Every Minute

A Grand Street Dance
at Sundown

You Are Earnestly Solicited, Entreated, Im-
plored and Commanded to Be Present
With All Your Friends

ET YOUR BASKET

Community events such as Floral City Heritage Days aren't a recent phenomenon however. This somewhat weathered photograph was taken in Lecanto in 1915 at the first Citrus County Fair. According to the handwritten notation, Judge E.C. May served as the auctioneer. Held at the fairgrounds in Inverness, the Citrus County Fair still takes place each March. (Citrus County Historical Society.)

Today almost every town in the county offers a variety of special occasions, festivals, parades, happenings, and other events to draw both visitors and local residents. In July 1920, Inverness was the site of what was advertised as the town's annual picnic. Promoters promised "Something Doing Every Minute" and invited attendance by saying, "You Are Earnestly Solicited, Entreated, Implored and Commanded to Be Present With All Your Friends." (Citrus County Historical Society.)

Running through Citrus County is a major portion of the Withlacoochee State Trail, officially termed "a linear state park." When service was discontinued along the 46-mile-long railway between Citrus Springs and Owensboro Junction, the State of Florida, under its newly instituted Florida Rails-to-Trails Program, purchased the right of way, completed removal of the rails, and paved the 12-foot-wide roadbed. Stops along the trail feature picnic areas, gazebos, restrooms, historical exhibits, and other amenities. Today the corridor is enjoyed by thousands of people of all ages who utilize the trail for hiking, biking, skating, and horseback riding. Railroad buffs can still find evidence of past railroad activity in the mileage and whistle markers, the Lake Henderson trestle, and the former depot at Inverness. Sharp eyes may even spot an old iron railroad spike lying along the path every now and then, while nature lovers may cross paths with gopher tortoises, deer, river otters, turkeys, and the occasional wild hog or bobcat. (Citrus County Historical Society.)

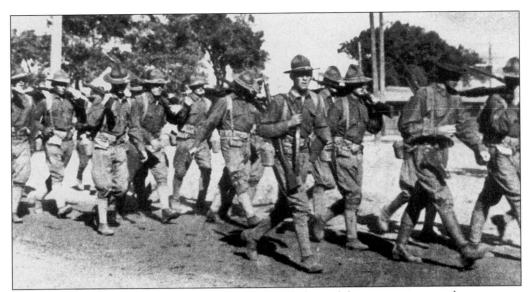

While people tend to think of the active pursuit of physical fitness as a recent phenomenon, this photograph, captioned as an Inverness Boy Scout troop out for a five-mile hike in 1915, seems to dispute that idea. Armed with rifles and dressed in uniforms complete with hats and puttees, the young men looked very much like the World War I soldiers many of them would become in just a few short years. (Citrus County Historical Society.)

Citrus County has always had a number of organizations for young people—Scout troops, Future Farmers of America, 4-H, school clubs, etc. In 1945, when the Catholic Church obtained property on Lake Tsala Apopka in Floral City, the Good Counsel Catholic Youth Camp was born. Several surplus buildings from the U.S. Army's Drew Field in Tampa provided hard-to-get construction materials, while the county used limerock from the site to build Gobbler Drive. (Jim Jernigan's Studio.)

Several hours of daily classroom work taught by nuns from Holy Name Priory in San Antonio, Florida, furthered the camp philosophy of bringing about a greater awareness of God and the Catholic faith. All was not religious instruction, however. The daily schedule for campers could also include handicrafts, archery, swimming, boating, canoeing, and all kinds of water sports. As these youngsters are demonstrating, nature trips, climbing, and hiking were also part of the curriculum. After supper, a session around the campfire rounded out the day. Since Good Counsel Camp officially opened in 1948, more than 25,000 children from across the Sunshine State have traveled to Citrus County to take part in camp activities. Nearly 500 young people have served as counselors. (Jim Jernigan's Studio.)

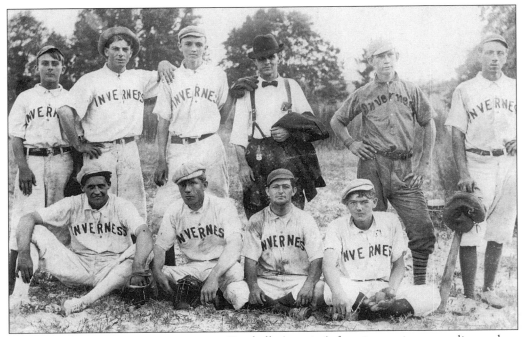

Baseball, America's favorite pastime, was alive and well in early Citrus County. Almost every town, including Inverness and Hernando, had a team. Every day after school, a pick-up game could be found; there were also organized leagues. At the turn of the 20th century, few occasions in the county were more anticipated than the annual Fourth of July celebration. Sometimes lasting several days, the events included parades, beauty contests, a barbecue or a fish fry, boat races, political speeches, and of course, several baseball games. Rivalries were intense, especially when the locals played teams from Tarpon Springs, Ocala, and Gainesville. One fan commented that "an invading army would receive better treatment than a rival ball team." Although the early teams were racially segregated, several teams of African-American players frequently shared the scheduled bill with their white counterparts. (Citrus County Historical Society.)

Nicknamed "The Kid" and the "Splendid Splinter," Ted Williams once said, "All I want out of life is that when I walk down the street, folks will say 'There goes the greatest hitter in the land.' " If the Citrus County resident didn't achieve that goal, he certainly came close to it. Today visitors to the Ted Williams Museum and Hitters' Hall of Fame in Hernando can relive the former Boston Red Sox player's career in a facility that is designed to resemble a baseball diamond and offers 18 galleries filled with paintings, photographs, and baseball memorabilia. Completed in 1994, the innovative museum is complete with an 80-seat sports theater in which baseball fans can experience the career highlights of the Red Sox's Number Nine. (Authors' Collection and Citrus County Tourist Development Council.)

For birding at its best, Citrus County is the place to be—a birdwatcher's paradise. Freshwater wetlands, salt marshes, mud flats, sandhills, flatwoods, hardwood hammocks, and the open water of lakes and rivers all provide the different habitats needed to attract a variety of birds. The Chassahowitzka National Wildlife Refuge, a more than 31,000-acre unspoiled estuarine habitat, runs along the county's west coast from near Homosassa at its northern boundary and extends southward into Hernando County. Established in 1943 to benefit wintering waterfowl, the refuge continues to provide a sanctuary for both resident and migratory birds. (Citrus County Tourist Development Council.)

More than 250 types of birds can be spotted in Citrus County. Varieties range from common songbirds to pelicans, herons, ospreys, egrets, and even threatened and endangered species such as bald eagles, woodstorks, and peregrine falcons. More than 23 kinds of ducks, swans, and geese have been spotted in the area. Recently Citrus County became the destination for Operation Migration, a flight of sandhill cranes led from Wisconsin by an ultralight aircraft. The unique event served as a 1,250-mile test run for a program intended to establish a migratory flock of endangered whooping cranes in the salt marshes of the Chassahowitzka National Wildlife Refuge. (Citrus County Historical Society and Citrus County Tourist Development Council.)

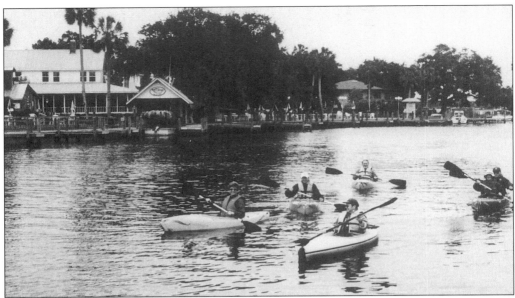

For a little close-up aquatic exploration of "Mother Nature's Theme Park," try snorkeling or diving in the county's spring-fed rivers and coastal waters. Prefer to remain on top of the water? Grab some friends and your kayaks and head downstream. Looking for a little competition? Enter either the Homosassa River Raft Race in June or wait until August and join the fun at the Crystal River Ramblin' River Raft Race. Whatever your preference, it's all available. (Citrus County Historical Society and Citrus County Tourist Development Council.)

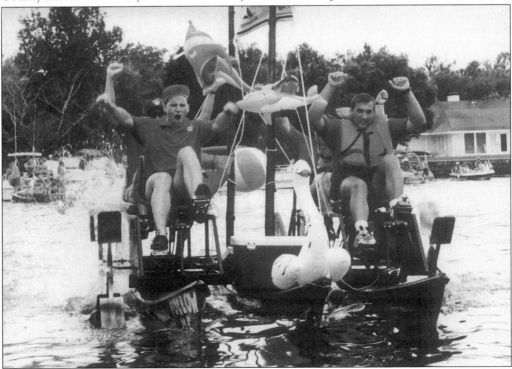

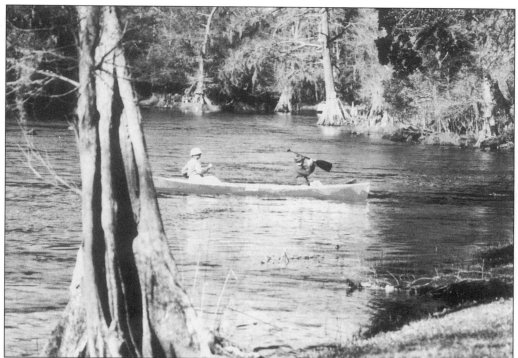

What better way to spend a quiet time outdoors than exploring the nooks and crannies of one of the many waterways of Citrus County? For those without their own kayak or canoe, dozens of places offer both guided tours as well as individual equipment rentals. Pack a lunch, dip your paddle into the water, and enjoy a day on the water. Just remember not to feed the alligators! (Citrus County Historical Society.)

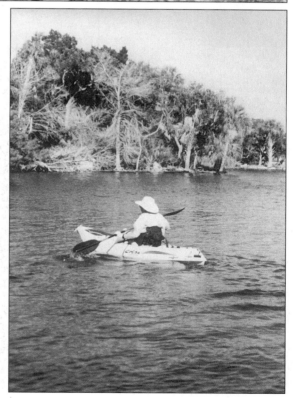

Vacationers and residents alike have always had plenty of opportunities for fun in Citrus County. In that respect, nothing has changed. Enjoy an ice cream soda. Go fishing or hunting. Pick a shady spot for a picnic. Catch a movie. Reenact an historic event. Attend a festival. Hike, bicycle, or roller-skate. Play a game of baseball. Do a little birdwatching. Paddle a kayak or a canoe. Frolic along the shore at sunset. Or, if one has played too hard, settle into a swing under a live oak tree and relax a little. (Mary Jane Lee and Authors' Collection.)

Six

VISITING PARADISE

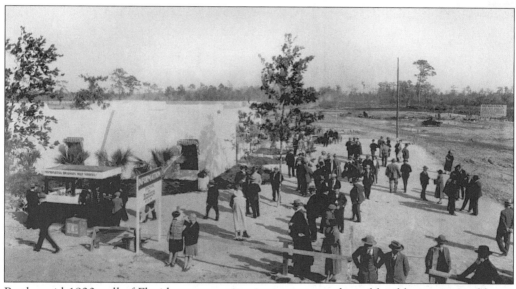

By the mid-1920s, all of Florida was experiencing an unprecedented land boom, spurred by an improved transportation network, favorable publicity, and the greed behind thousands of get-rich-quick schemes. This development office in Homosassa was only one of many that opened on an almost daily basis. Large firms, such as the West Coast Development Company, planned to create entire new communities, frequently designed with a Spanish or Mediterranean motif, while local entrepreneurs hoped to sell and resell smaller pieces of property. Thousand-acre subdivisions in Citrus County, including Fairview Heights, Citrus Gardens, Lakeshore Park, and Indian Hill, were planned, but never happened. In 1925, Max Wellborn, chairman of the Federal Reserve Bank, wrote, "Everything is magnified and exaggerated. The bright sun shines upon the largest and most varied collection of thieves ever before gotten together in any clime—they hesitate at nothing." By late in 1926, the boom was slowing. By 1927, the bottom had fallen out of the real estate market. Nevertheless, visitors still continued to come to Florida. (Tampa-Hillsborough County Public Library System.)

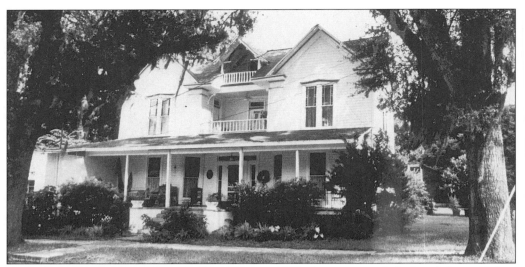

With the coming of the railroad to Floral City in 1893, the town needed a hotel. James Baker, a phosphate mine operator and owner of the finest residence in town, was quick to fill that need. Baker's two-story Queen Anne–style residence was moved closer to the rail depot and converted into the Commercial Hotel, catering to both businessmen and vacationers. For many years, it was well known for both its accommodations and fine dining. (Citrus County Historical Society.)

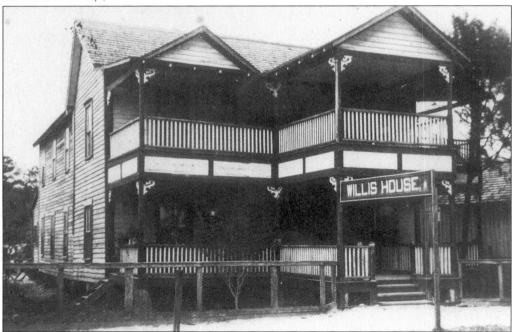

In Crystal River, vacationers needing a place to stay had their choice of several hotels. J.W. Willis, proprietor of Willis House, published advertisements promising, "Modern Hotel, First Class Service, Airy Rooms, Special Attention to Tourists." Unlike many Florida hotels that catered to northern visitors, Willis House, also known as the Hotel Willis, was open all year, not just during the winter tourist season. (Citrus County Historical Society.)

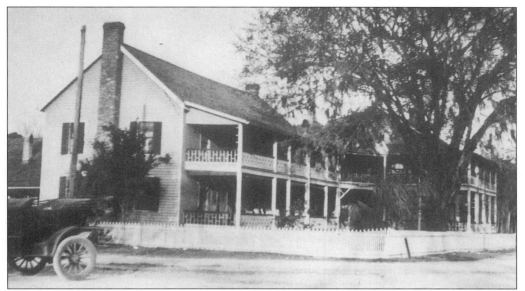

Proclaiming itself Crystal River's leading hotel, Dixon House was built originally to house visitors to both the Joseph Dixon Crucible Company and the community of Crystal River. Located on the Dixon Company property, the hotel was purchased by Harvey and Ada Edwards when the mill was sold in 1919. The 16-bedroom hostelry provided accommodations for hunters and fishermen until it was demolished in the late 1950s. (Citrus County Historical Society.)

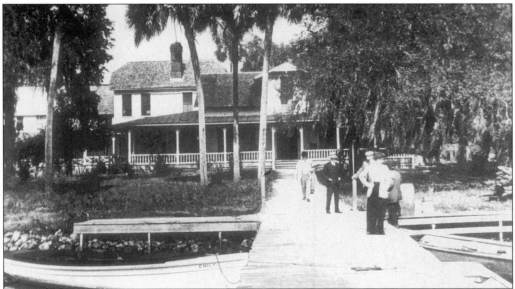

The Rendezvous Inn, situated on the Homosassa River, was just one of the many sportsmen's lodges in the area. Attracted by the excellent hunting and fishing, wealthy businessmen found the county a perfect place in which to get away from it all and pursue their favorite pastimes. Reputedly Grover Cleveland was one of the guests who came to the Rendezvous Inn for just that reason. Riverside Marina presently occupies the site of the demolished lodge. (Citrus County Historical Society.)

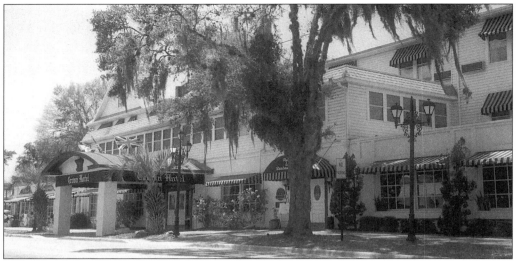

The history of the Crown Hotel is almost as old as that of Inverness itself. Originally owned by Francis Dampier, the enterprise began in the early 1900s as a store, later became a boarding house, and subsequently was relocated, enlarged, and renamed. Under various owners, it has been known as both the Orange Hotel and the Colonial Hotel. With its purchase in 1980 by Epicure Investments, the establishment took on a British flavor and was renamed the Crown Hotel. (Citrus County Historical Society.)

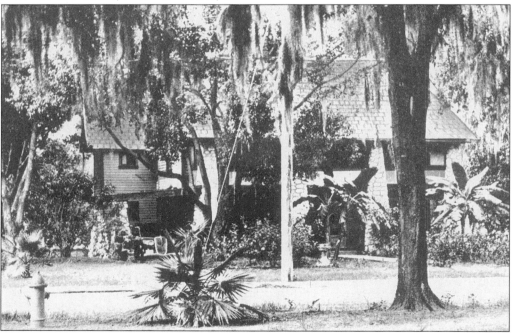

For those wishing to rent an apartment rather than just a room, "The Haven" advertised "Hot and cold water, private baths, electric refrigeration and light. Also china and utensils." On a more medicinal note, the owners proclaimed, "Our pure drinking water is responsible for the physical improvement in many who have been with us. Especially those who had heart and stomach troubles. No contagious diseases received." (Citrus County Historical Society.)

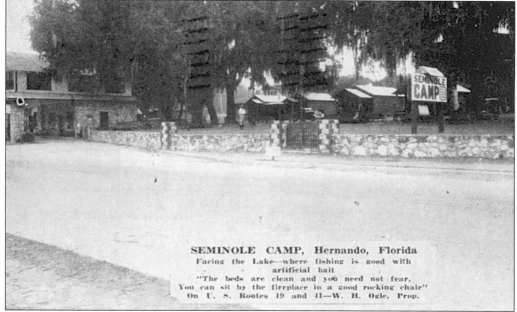

SEMINOLE CAMP, Hernando, Florida
Facing the Lake—where fishing is good with
artificial bait
"The beds are clean and you need not fear,
You can sit by the fireplace in a good rocking chair"
On U. S. Routes 19 and 41—W. H. Ogle, Prop.

With the increasing popularity of the automobile, a different kind of place to stay came into being. Hotel accommodations were augmented by tourist camps, motels, and motor courts. American society had become more mobile; by 1950, vacationers were driving more than one million cars into Florida each year. The more affluent visitors of previous years who had come for extended periods of time were being replaced by families with less money and less time to spend before moving on to their next destination. The Seminole Camp in Hernando advertised, "The beds are clean and you need not fear, You can sit by the fireplace in a good rocking chair. On U.S. Routes 19 and 41." It also featured gas pumps in front of the building for the convenience of its motoring guests. Catering to those traveling by car, Woody's Motor Court, just down the highway in Inverness, indicated its clientele in its name. (Citrus County Historical Society.)

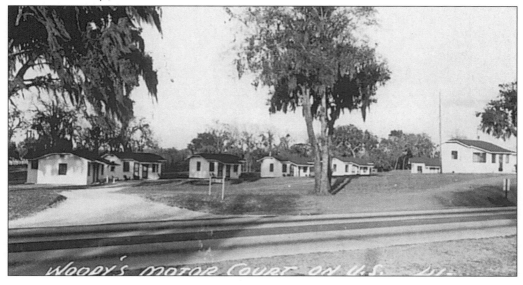

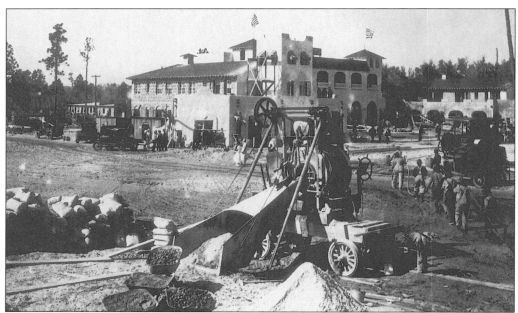

Although the 1920s real estate boom in Citrus County ended before ever reaching the expectations of promoters, it did produce at least one splendid edifice—the magnificent Homosassa Hotel. Built by the West Coast Development Company, the hotel and its accompanying business and shopping arcade were to be the centerpieces of the planned community of New Homosassa. Requiring almost a year to build and typical of the fantasy architecture of the period, the hotel featured ornate Mediterranean detailing, including stuccoed walls, arched windows, balconies, and a red tile roof. Advertisements touted the hotel as "A Sportsman's Paradise" that offered amenities such as "Long Distance Phones," a "Post Office in Hotel," and a "Garage and Repair Shop." Well-known guests included baseball players Babe Ruth, Dazzy Vance, and George Pipgras. The hotel was demolished in the 1960s to clear the way for a new shopping center. (Citrus County Historical Society.)

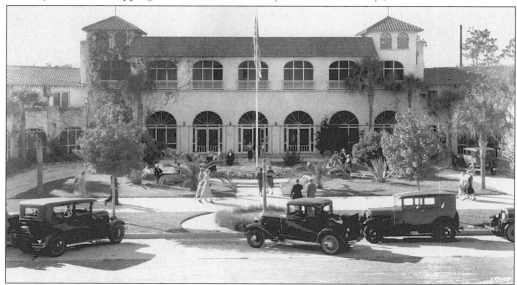

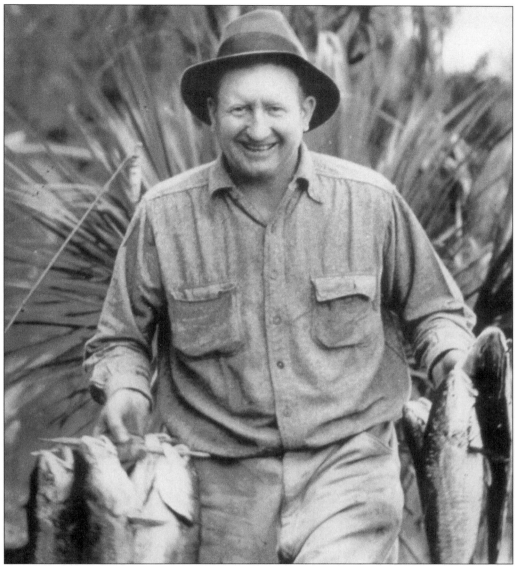

Pictured with his fine catch of fish, Clarence Arthur Vance, better known as Dazzy, was a well-known Homosassa Springs resident. Born in Orient, Iowa, in 1891, Vance played several years of minor league baseball before making it to the major leagues. Spring training in Florida introduced Dazzy, an avid hunter and fisherman, to the joys of the Sunshine State, where he eventually fell in love with Citrus County. In 1930, in partnership with several other investors, Vance purchased the Homosassa Hotel from the West Coast Development Company. Following his retirement from professional baseball, he became a permanent resident of Homosassa Springs. In 1955, Vance was elected to the Baseball Hall of Fame at Cooperstown, New York, with a record boasting 197 wins, 140 losses, and 2,045 career strikeouts. Before his death in 1961 in his adopted hometown of Homosassa Springs, Vance was actively involved in several local baseball leagues. Buried at Stage Stand Cemetery, Vance lives on in local memory with the Homosassa athletic field named in honor of baseball's "Most Valuable Player of 1924." (Citrus County Historical Society.)

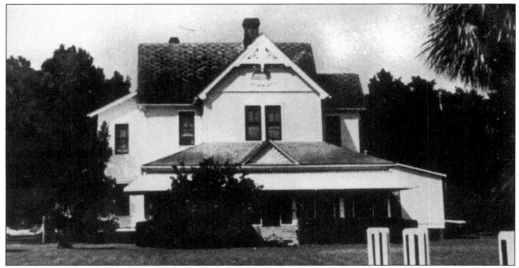

It takes very little imagination to realize how the Atlanta Fishing Club got its name. Several well-to-do Atlanta businessmen enjoyed their annual fishing trips to Citrus County so much that they decided they needed their own fishing lodge. By 1904, the private club had been officially chartered with two dozen members. Located in Homosassa next door to what is today the popular K.C. Crump restaurant, the Atlanta Fishing Club was just one, albeit a more exclusive example, of several fishing lodges in town. (Citrus County Historical Society.)

Maggie Harmon Smith's Tackle and Sandwich Shop was a Chassahowitzka institution for more than 40 years. Born on Tiger Tail Island in 1901, Maggie Smith moved to Chassahowitzka when she was 19 years old. Located on the Chassahowitzka River, her store provided local and out-of-town fishermen with bait for reeling in record catches. The town's main street, Miss Maggie Drive, is named in her honor. (Citrus County Historical Society.)

Many of the tourists who visit Citrus County today come for the sport fishing, just as visitors have for more than 100 years. These fishermen posing with their catch at Knox's Bait House in Crystal River were obviously proud of their day's accomplishment. With nearly 40 kinds of fish from which to choose, both freshwater and saltwater fishing aficionados can opt for either the county's lakes and rivers or the Gulf of Mexico. (Citrus County Historical Society.)

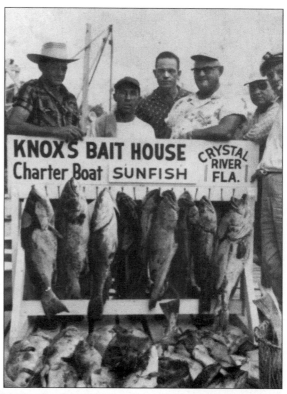

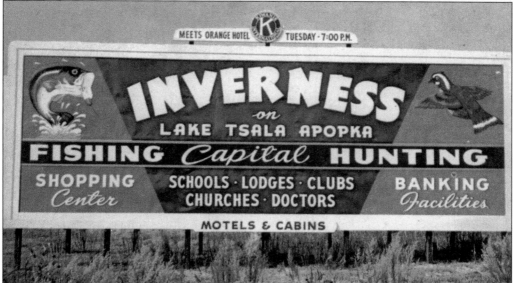

This sign on the outskirts of Inverness told the story. Calling the area the hunting and fishing capital, business promoters touted amenities that included motels, cabins, schools, lodges, clubs, churches, doctors, banking facilities, and a shopping center. Obviously, the community felt that it had everything that either visitors or potential residents could desire. (Citrus County Historical Society.)

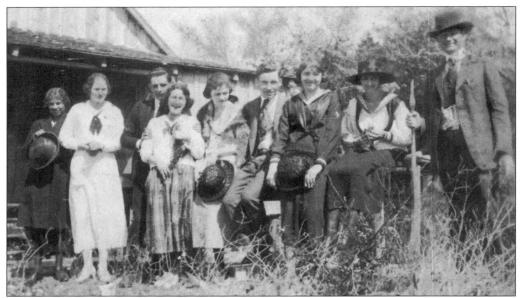

Even if vacationers weren't fishermen or boaters, they could still find plenty to do in Citrus County. Shell Island, located just off the mainland in Crystal Bay, was the site of a summer resort in the early 1920s. According to the inscription on the photograph, this group of young people had come to Shell Island for a picnic in 1921. Judging from their attire, however, swimming was not part of the day's agenda. (Citrus County Historical Society.)

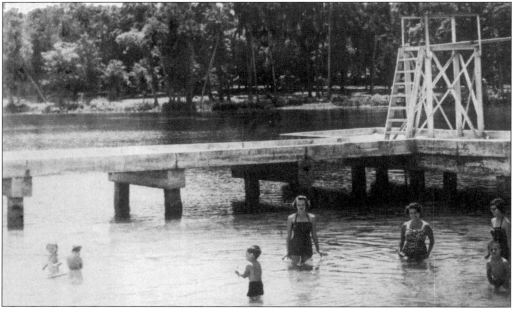

Styles were a little less formal by 1955. Two local women, Peggy Lewis and Sara Barnes, brought a visitor from Michigan to swim at Hunter Springs. One of the nicest things about swimming in any of the many springs in Citrus County is the constant temperature of the water—a year-round 72 degrees. The outstanding clarity of the water is an added bonus. (Citrus County Historical Society.)

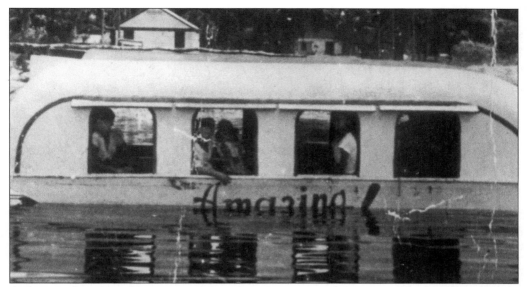

As long as there have been tourists, there have been tourist attractions. Used as a tour boat in King's Bay for six years during the 1940s, Jesse Hatfield's glass-bottomed boat, *Amazing*, provided visitors with an underwater look at marine life without getting wet. Pictured in the boat are five members of the Hatfield family. (Citrus County Historical Society.)

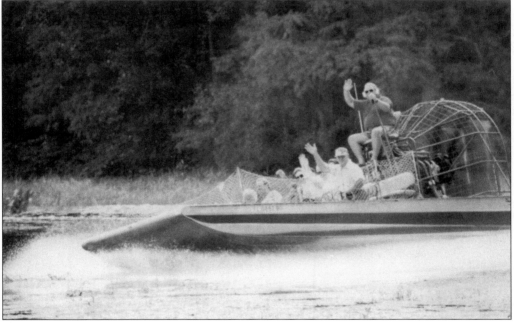

For those with a spirit of adventure, there is no more exciting way to travel the Withlacoochee River than aboard one of Wild Bill's airboats. Visitors can treat themselves to a somewhat noisy bit of old-fashioned Florida as they cruise up and down the river. The airboats, propelled by what appears to be a giant fan, are designed to glide across grasslands and shallow water. Located in Inverness, Wild Bill also maintains a wildlife sanctuary that is home to a number of exotic animals. (Citrus County Tourist Development Council.)

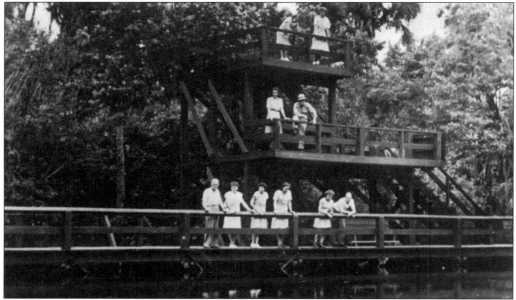

Nature lovers have been drawn to the springs at Homosassa for centuries. Native Americans visited the source of the Homosassa River for both drinking water and the many varieties of fish, both freshwater and saltwater, that congregated there. By the early 1900s, a wooden pier had been built over the spring in order for visitors to view and feed the fish. In the late 1930s, David Newell, a past editor of *Field and Stream* magazine, purchased the spring and surrounding acreage and began development of a tourist attraction he called Nature's Giant Fish Bowl. A submarine-type walkway underneath the spring allowed visitors to view the marine life through small windows. When the Norton Development Company purchased the property in 1962, they made many changes, including the installation of a giant glass-walled 168-ton observatory in the center of the spring. With its newly added features, including boat cruises, nature trails, and wild animal displays, the renovated facility was renamed the Homosassa Springs Attraction. (Citrus County Historical Society.)

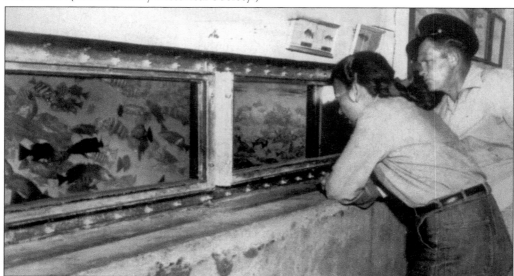

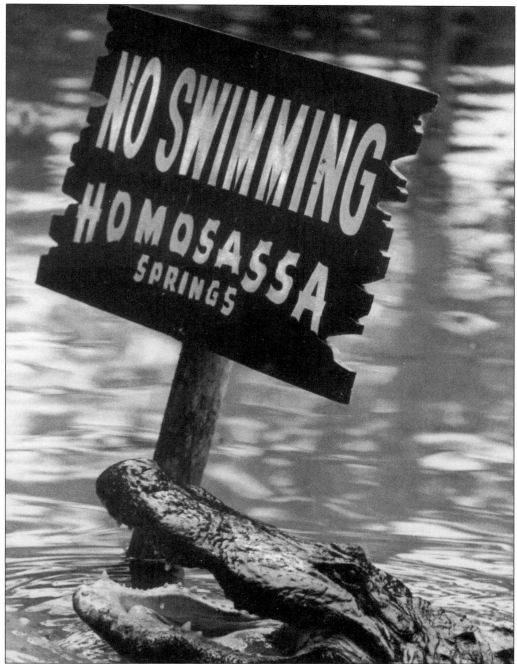

Everyone with a camera dreams of someday capturing that perfect image. With this very tongue-in-cheek shot, professional photographer Bob Moreland achieved that goal. Appearing in publications around the world, the photo was and still continues to be the ideal publicity picture for the Homosassa Springs Attraction, today known as Homosassa Springs State Wildlife Park. Along with considerable recognition, the photograph also brought Moreland the first prize in the National Press Photographers Contest. (Citrus County Historical Society.)

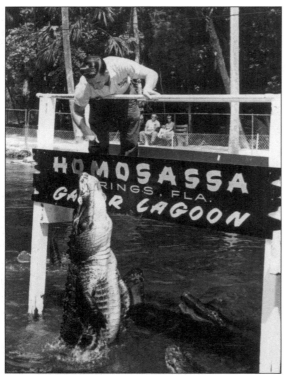

Under the Norton Company's management, the Homosassa Springs Attraction featured Otter Village, a Waterfowl of the World Park, Sea Lion Spring, a deer park, and more. Certainly one of the most popular activities was a visit to Gator Lagoon in time to witness the alligator feeding. In 1984, Citrus County spent $3.8 million to purchase the facility, only to sell it to the State of Florida four years later. With that transaction, the park became known as Homosassa Springs State Wildlife Park. (Citrus County Historical Society.)

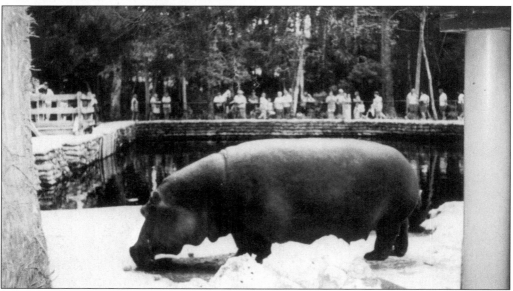

Although not indigenous to Florida, Lucifer the hippo has long been one of the stars of the show at the Homosassa Springs State Wildlife Park. During the years when the attraction was an exotic animal park, Lucifer appeared in several movies shot on the premises. After the park management changed, the new owners wanted to remove the hippo, but local residents argued that he should be allowed to remain. Now, as park literature states, "Lu was granted honorary state citizenship." (Citrus County Tourist Development Council.)

From the visitors' center at Homosassa Springs State Wildlife Park, passengers board a pontoon boat for a 20-minute ride to the center of the 166-acre park and their destination, the Fish Bowl. Along the way, guides provide detailed information on the abundant native flora and fauna. At the Fish Bowl, visitors enter the underwater observatory to view fish, turtles, and manatees traveling between the headwaters of the Homosassa River and the Gulf of Mexico. (Citrus County Tourist Development Council.)

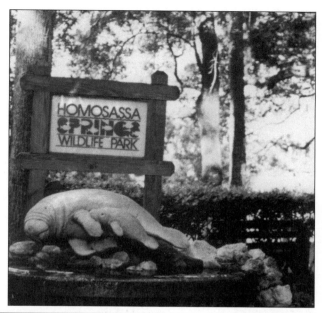

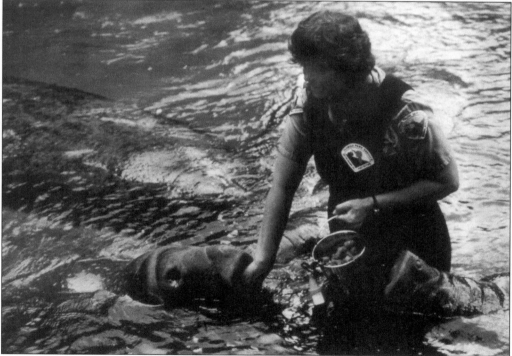

A park ranger at Homosassa Springs State Wildlife Park tends to the care and feeding of several West Indian manatees. Closely related to the elephant, the manatee is a herbivore that dines on aquatic plant life. Feeding from six to eight hours each day, it ingests the equivalent of 10 percent of its body weight. With the approach of cold weather, the manatees increase their caloric intake since they require additional energy to stay warm in cooler water. (Citrus County Tourist Development Council.)

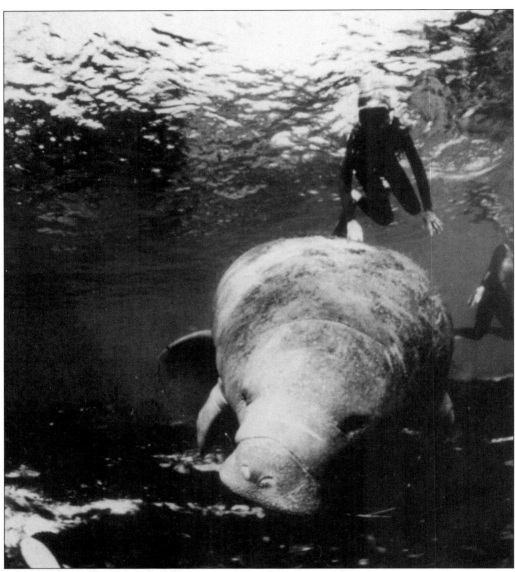

A West Indian manatee, Latin name *trichechus manatus*, lumbers along underwater at the Homosassa Springs State Wildlife Park. As manatees move through the water, their flat horizontal tails pump up and down. Although they generally surface to breathe every two to four minutes, they can remain submerged for as long as one-quarter hour. The massive gray-brown animals, growing to a length of 13 feet and a weight of 3,000 pounds, are not aggressive. In fact, their only enemy is man. Most manatees in the wild bear scars from boat propellers on their tails and tough wrinkled backs. Once hunted as a source of food, lamp oil, and clothing, the manatee has been on the brink of extinction for a number of years. Although they are now protected by a number of laws, including the Endangered Species Act, the Marine Mammal Protection Act, and the Florida Manatee Sanctuary Act, the manatee continues its struggle to survive. Watching these gentle but rather portly creatures, it's hard to understand how sailors of old believed them to be beautiful and curvaceous mermaids. (Citrus County Tourist Development Council.)

114

Seven

AN ENDURING PRESENCE

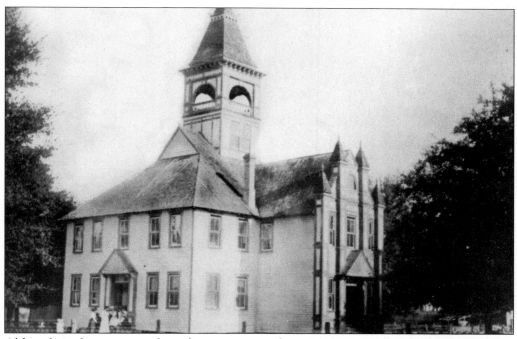

Although its location may have been a source of controversy initially, the county seat has always meant more than just the center of judicial and governmental activity. As discussed earlier, Mannfield had been the site of the first county seat, and today many Citrus County government offices are located in the administrative complex in Lecanto. For most residents, however, the county seat was and is still symbolized by the county courthouse in Inverness. In 1891, Henry Martin, president of Florida Orange Canal and Transit Company, offered a one-acre site in the center of town as the site for a new courthouse. By the end of 1892, an impressive two-story wooden structure was completed. The ornate Victorian-style edifice, painted white with dark red trim, would serve as the center of Citrus County government until a larger building was deemed necessary in 1911. (Citrus County Historical Society.)

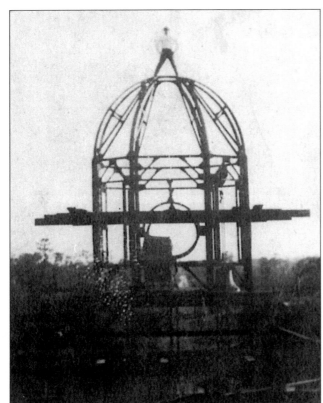

Late in 1911, an architect, Willis R. Biggers, and a builder, the Read-Parker Construction Company, were selected to design the new courthouse. Within months, the old building had been sold and removed from the site. The project quickly began to take shape. Plans included a clock tower and a domed cupola. As this photograph proves, one worker couldn't resist the impulse to be immortalized standing atop the still-incomplete dome. (Citrus County Historical Society.)

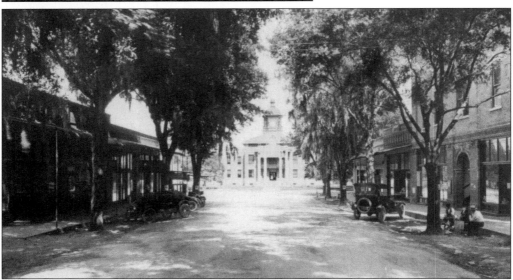

Twenty-six years to the day from the official establishment of the county, on June 2, 1913, the contractors announced that the new courthouse was ready for occupancy. Although the final cost was $55,885, nearly 11 percent over bid, the Board of Commissioners accepted the building the following day. Surrounded by gas lampposts and an ornamental fence, the magnificent building was obviously the focal point of Main Street. (Citrus County Historical Society.)

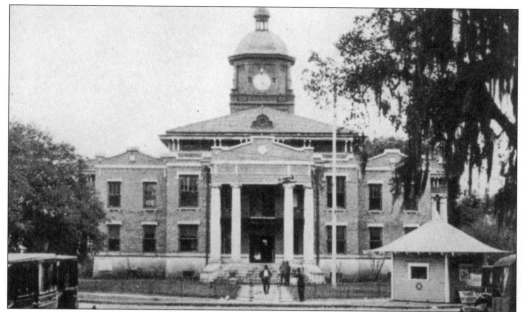

More than three times larger than the Victorian courthouse, the finished structure featured an exterior of pale beige bricks above large concrete foundation blocks. Imposing white columns surrounded each of the four entrances, while white trim accented the windows and building facade. Copper sheeting covered the clock tower and dome. A red tile roof and brown window and doorframes completed the exterior color scheme. (Citrus County Historical Society.)

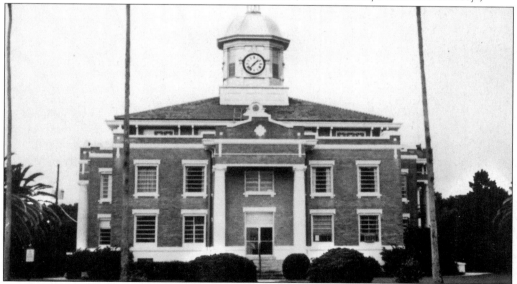

Unfortunately the building's beauty wasn't to last. In the name of modernization, many of the unique architectural details, both interior and exterior, disappeared over the years. White paint covered the copper sheeting on the clock tower. Metal-and-glass entrances and louvered windows replaced the original wooden window and doorframes. Window air-conditioning units may have made the interior temperatures more comfortable but hardly enhanced the building's appearance. (Citrus County Historical Society.)

Although the courthouse still held a few remaining offices until the late 1980s, its lack of space and state of disrepair necessitated the building of a replacement. By 1979, a new brick building costing more than $1 million and located just one block away on North Apopka Avenue became the latest Citrus County Courthouse. Pictured against the glass windows of the second and third floors are the flags of the United States and Citrus County. A multi-million-dollar expansion in 2001 will provide additional space to accommodate the needs of a growing county. (Citrus County Historical Society and the Citrus County Tourist Development Council.)

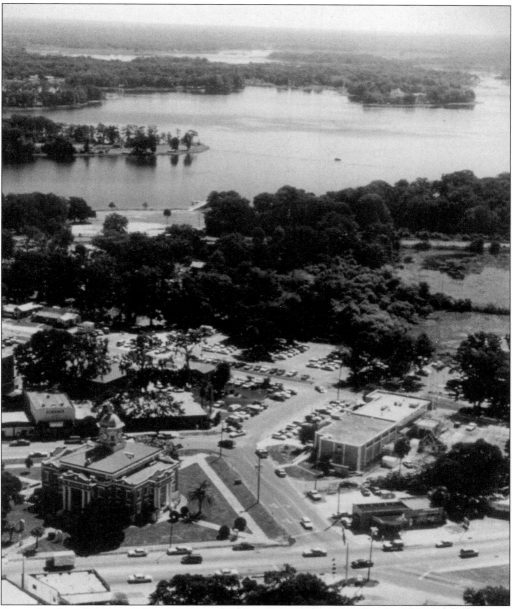

One of only a few original county courthouses remaining in Florida, the old courthouse was, unfortunately, in sad shape. Judge Mark J. Yerman recalled, "I was the last judge to regularly hear cases in this old historic courthouse and I was driven out, not by the dust and mold, not by the failing heating and air conditioning system, not even by the walls painted pink. I was finally forced out by the ceiling collapsing near the old witness box." The building still had several points in its favor, however. Although considerably altered in appearance, none of the changes to the courthouse were irreversible. Its downtown location adjacent to scenic Lake Henderson was certainly a factor. Even more significant was the unusual diagonal placement of the building on its square site, making it the only courthouse in Florida, and perhaps even the nation, to be situated thusly. (Citrus County Tourist Development Council.)

The old courthouse still retained several significant elements. Housed in the four-sided tower atop the building is one of the most important—the original clock mechanism with its large cast-bronze bell. Complete with four wooden faces, the clock mechanism was purchased in October 1911 for the sum of $800. Still in working order, the clock chimes regularly to announce the time to all within hearing distance. Although translucent replacement clock dials have been installed in the tower, the original wooden faces are part of an exhibit in the Old Courthouse Heritage Museum operated by the Citrus County Historical Society. Augmented by a variety of later graffiti, the reverse sides of the faces are inscribed with signatures of civil defense workers, dating from the days when the clock tower was used as a World War II observation post. (Citrus County Historical Society.)

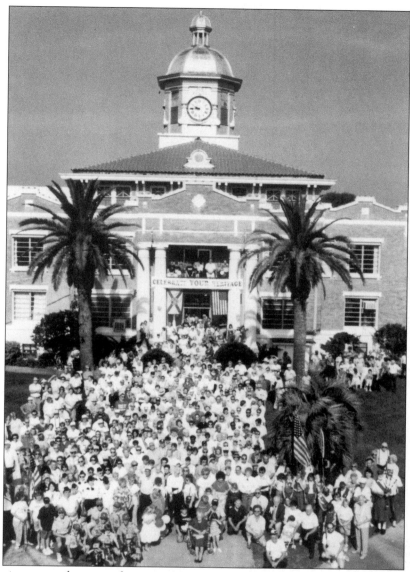

No longer in use as the seat of county government, the old courthouse faced an uncertain future. Despite its condition, it was still considered to be Citrus County's most architecturally significant building. As such, it was listed on the National Register of Historic Places in 1992. Recognizing the building's importance to both present and future Citrus County residents, a committee was formed by the Citrus County Historical Society to lead a restoration effort. More than $2.5 million would be needed to remove the effects of time plus the ravages of insensitive remodeling and to restore the building to its former grandeur. Although some funding would come from the State of Florida, much of the money would have to be raised locally. Thousands of hours of volunteer labor would be involved. The Old Courthouse, as it would come to be known officially, still had a most important factor working in its favor, however. Led by the Citrus County Historical Society, the people of Citrus County would make the project succeed. Pictured on Historic Preservation Day in May 1994, are a few of the project's supporters. (Citrus County Historical Society.)

Having determined that the former courthouse was worth not just renovating, but returning to its original grandeur, the restoration committee began what would become an eight-year task. An architect was retained to design a master plan for the now closed and boarded-up building. The project would be divided into phases that could be completed as financing, whether state, local, public, private, or as actually happened, a combination of all four, became available. Certain modifications would have to be made to permit fire safety, climate control, and handicapped accessibility, features that had not been part of the original 1912 design. Sledgehammers pounded into the building as the existing metal windows and doors were torn out and wooden replacements installed. A special surprise was the discovery of the sash weights from the original windows buried in the concrete sills. (Citrus County Historical Society.)

Once the new windows and doors had been installed, the project moved on to the rest of the exterior. The building needed to be thoroughly cleaned, with sandblasting required in some places. Leaks had to be fixed; missing granite in the foundation was replaced. All of the brick and masonry work was repaired and repointed. Paint was stripped from the cupola and dome, and repairs were made to the clock tower. New roof tile was obtained from the same company in Galion, Ohio, who had manufactured the roofing materials in 1912. Tenting killed the infestations of termites and other insects. (Citrus County Historical Society.)

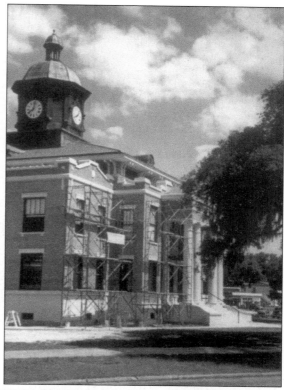

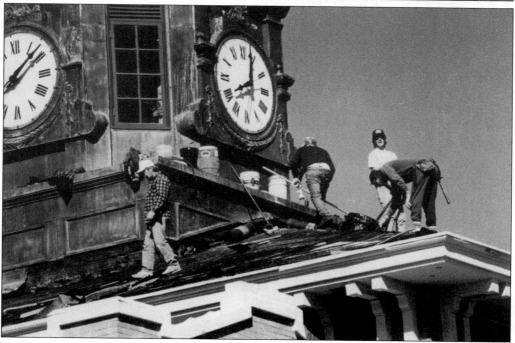

With the outside of the building finally completed, the restoration moved indoors, beginning on the first floor, and then moving to the second. The installation of a steel fire staircase in the southwest corner of the courthouse was a complicated procedure. Metal jacks had to be put in place to provide support while removing a layer of concrete separating the first and second floors. Workers installed new electrical wiring and plumbing. Fireplaces that had been concealed in the past were uncovered, although they are no longer operative. Marble paneling in hallways was replaced; layer upon layer of paint was removed from woodwork. In some areas, even the glass windowpanes had to be stripped of paint. Plaster on walls and ceilings was repaired or replaced. The job went on and on, as volunteers added thousands of hours of their labor to those of the workmen. (Citrus County Historical Society.)

Phase IV targeted the building's second floor. Restrooms, including one with a fireplace, received modern plumbing. Office spaces were renovated and once again include the rounded glass windows on interior walls. In order to refinish the hardwood flooring, it proved necessary to remove layers of carpet, linoleum, and even, in places, concrete. Hidden behind a dropped ceiling since the 1960s, the courtroom balcony was uncovered and restored. (Citrus County Historical Society.)

Restoration of the main courtroom was the focal point of the final phase of the project. Returning the room to its original configuration required relocation of walls and doors. Removal of a dropped ceiling revealed amber windows in the upper portions of the walls. Giving the room a soft golden glow, the leaded-glass panes augment light from reproduction hanging light fixtures appropriate to the period. As the final touch, craftsmen reproduced the judge's bench and wooden courtroom railing. (Citrus County Historical Society.)

During the course of the eight-year restoration, state officials provided ongoing support for the project. In September 1996, while campaigning in the area on behalf of candidates for political office, Gov. Lawton Chiles toured the interior restoration of the courthouse. His interest in both the building's refurbishment and the historical exhibits on display contributed to an excellent photo opportunity. (Citrus County Historical Society.)

Centered on the floor of the rotunda is one of the building's most interesting original architectural elements, a mosaic depiction of the Great Seal of the State of Florida. Since adopting the design in 1868, the legislature has modified the official conceptualization several times to more accurately represent the state and its qualities. Comprised of thousands of small pieces of tile, this particular rendition contains several inaccuracies included in the 1868 design, along with a couple of artistic errors. (Citrus County Historical Society.)

ORDER BOOK

CHANCERY ORDERS
& DECREES
10

CHANCERY ORDERS
& DECREES
11

CHANCERY
ORDERS &
DECREES
12
CITRU
COUNT
FLORID

CHANCERY
ORDERS &
DECREES
13
CITRUS
COUNTY,
FLORIDA

In the southeast corner of the first floor is the former office of the county clerk. Today this area serves as the library for the Old Courthouse Heritage Museum, while its adjacent vault houses a treasure trove of historical data. Among the historically significant materials stored under climate-controlled conditions are the official records of the county clerk, sheriff, property appraiser, tax collector, and board of commissioners, spanning a period of more than 100 years. Newspapers dating back to 1888, diaries, business ledgers, poll tax records, marriage registers, chancery orders, and other information provide additional documentation of the county's history. Both the library and the archives vault are operated by the Citrus County Historical Society and are accessible to researchers by appointment. (Citrus County Historical Society.)

On November 21, 2000, more than 3,000 Citrus County residents turned out to celebrate the official dedication of the beautifully restored Old Courthouse. Festivities included a flag-raising ceremony by a U.S. Marine Corps color guard, musical presentations by school bands, and of course, speeches by various dignitaries. With the opening of the doors, the public then poured into the building to marvel at the restoration and to tour the historical exhibits. Today, the Old Courthouse Heritage Museum provides a magnificent setting in which every visitor can learn more about the history of the area. For those of any age, including the youngsters who are the future of Citrus County, it provides a glimpse of the past as well as a look at tomorrow. (Vernina Gray and Citrus County Historical Society.)